IMAGES
of America

MONHEGAN ISLAND

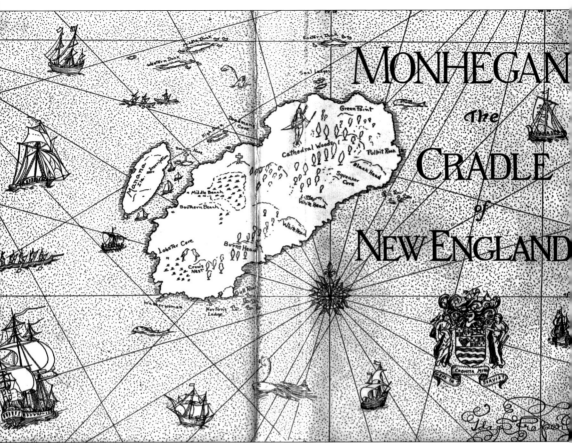

This map of Monhegan Island appeared on the cover of *Monhegan, the Cradle of New England* by Ida Proper, published in 1930.

On the cover: While exploring the New England coast, Capt. John Smith anchored in the Monhegan harbor in 1614. Monhegan Plantation and the Maine Historical Society celebrated this momentous occasion 300 years later on August 6, 1914. For this tercentenary gala celebration, all manner of flags and buntings were displayed on the wharf, boats, hotels, and private residences. This elaborately decorated arch was erected near the top of Wharf Hill for all to pass through to attend the festivities at the schoolhouse. (Courtesy Monhegan Museum Collection.)

IMAGES
of America

MONHEGAN ISLAND

Margot Sullivan, Cynthia Hagar Krusell,
and John J. Galluzzo

ARCADIA
PUBLISHING

Copyright © 2009 by Margot Sullivan, Cynthia Hagar Krusell, and John J. Galluzzo
ISBN 978-0-7385-6465-4

Published by Arcadia Publishing
Charleston SC, Chicago IL, Portsmouth NH, San Francisco CA

Printed in the United States of America

Library of Congress Control Number: 2008939200

For all general information contact Arcadia Publishing at:
Telephone 843-853-2070
Fax 843-853-0044
E-mail sales@arcadiapublishing.com
For customer service and orders:
Toll-Free 1-888-313-2665

Visit us on the Internet at www.arcadiapublishing.com

*In memory of those island residents no longer around to fish,
lobster, tell stories, and play cribbage.*

CONTENTS

ACKNOWLEDGMENTS

But the first salt wind from the east, the first sight of a lighthouse set boldly on its outer rock,
the flash of a gull, the waiting procession of seaward-bound firs on an island, made me feel solid
and definite again, instead of a poor incoherent being. Life was resumed, and anxious living
blew away as if it had not been. I could not breathe deep enough or long enough.
It was a return to happiness.
—Sarah Orne Jewett, from *The Country of the Pointed Firs*

The authors would like to thank the following individuals and organization for their help in creating this book. The Monhegan Historical and Cultural Museum supplied many of the images. Other images are from the collection of Cynthia Hagar Krusell and a few are from the collection of Margot Sullivan. Unless otherwise noted, all images are courtesy of the Monhegan Historical and Cultural Museum. The staff of the Monhegan Museum has been of inestimable value in answering our questions regarding old photographs and island history. We thank Tralice Bracy, senior curator, and give special thanks to Jennifer Pye, curator of collections, for her patience, time, and suggestions. We also thank Esther Coke for her work with the images and Frances Vaughan for her editing expertise. We are indebted to Ruth Faller and her definitive book *Monhegan: Her Houses and Her People* for the wealth of information provided. We acknowledge the efforts of historians and other chroniclers of the past who have worked before us to keep the traditions of Monhegan alive.

INTRODUCTION

Monhegan, located at the mouth of Penobscot Bay about 10 miles off the coast of Maine, has been a place known and frequented from the days of the Abenaki tribes of northern New England. It was discovered by Europeans in the 15th century and quickly became a prized fishing ground for Scandinavian, English, French, and Basque fishermen. Early explorers, including George Weymouth in 1605 and Samuel de Champlain in the same year and John Smith in 1614, touched in at this island off the central Maine coast. The English Puritan Pilgrim settlers at Plymouth, Massachusetts, frequently sent members to obtain fish and supplies at Monhegan. Edward Winslow, Pilgrim ambassador and later governor of Plymouth Colony, visited the island in 1622 as recorded in his *Good News from New England*.

One of the early owners of the island was Shem Drowne, an artisan who designed the grasshopper weather vane that graces Faneuil Hall in Boston. By 1790, Henry Trefethren had settled on the island with his family and two sons-in-law Josiah Starling and Thomas Horn. These families divided Monhegan into three parcels. Descendants of these families lived for generations on the island, some down to the present day. Fishing continued to be the major activity and source of livelihood. A saltworks was built, and considerable land was given over to tillage and pasturage. Farming was a necessity for all.

Life on the island took a new turn in the late 19th century, when several small inns and hotels began to accommodate the increasing number of summer visitors. These early tourists took a steamer from Boston or Portland to Rockland, and from there another boat took them out to the island. They arrived with steamer trunks with plans to spend the summer. As time went on, some built their own cottages, and the village began to spread outward along the one-and-only road. A number of stores opened, some for groceries and others for dry goods and souvenirs. A school was built for the year-round children, and a church was constructed for the residents.

The artists who were to make Monhegan known throughout the world started arriving around 1900. The early painters included George Bellows, Robert Henri, and Eric Hudson. Soon it became an artists' haven, attracting such famous figures as Rockwell Kent, Jay Connaway, Andrew Winter, Alice Kent Stoddard, Charles Ebert, S. P. R. Triscott, Abraham Bogdanov, and by the end of the 20th century, the renowned Wyeth family, particularly Jamie Wyeth. The island also attracted writers, musicians, and famous people such as Zero Mostel and Moshe Paranov.

Fishing and lobstering continued. Monhegan has a limited lobster season from the first of October to the end of May. It begins with a celebration called Trap Day, when all the lobstermen rush to reach the prime lobster areas to set their pots. Although the waters around the island are a good source for fish and lobsters, the Monhegan fishermen go further to the rich fishing banks

off the New England coast. The island lighthouse was built as a navigational aid in 1824 and a fog station erected on adjacent Manana Island in 1854.

Today the tourist boats come out to the island from Boothbay Harbor, New Harbor, and Port Clyde. The mail boat, so important to the island, comes year-round from Port Clyde. The day-trippers arrive just before noon and spread out over the island. They hike the magnificent trails to the high cliffs on the Atlantic side, visit the artists' studios, pick up a bite to eat, create a painting, or just sit and watch the people and the scenery and marvel at this magical place off the coast of Maine.

One

AROUND THE VILLAGE

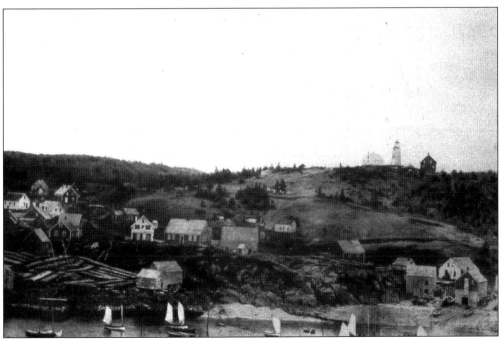

Monhegan Island harbor has been the subject of many, many photographs for its picturesque landscape, fishing activity, and village buildings lining the shore. This is an early photograph of the harbor. Clearly shown are the fish houses on the right, the lighthouse, and the very open, bare landscape. (Cynthia Hagar Krusell.)

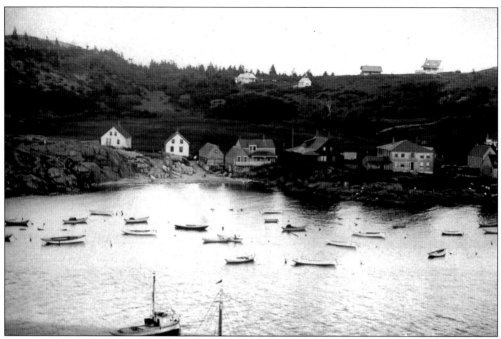

This view of the shoreline and harbor shows fishing vessels and skiffs. The small beach left of center is still Swim Beach. Beside it was the dark house, built around 1784 by Henry Trefethren when he was first married. The artist Jamie Wyeth made the so-called red house famous in one of his paintings. Next to the dark red house is the square house, the Influence, built in 1826. (Cynthia Hagar Krusell.)

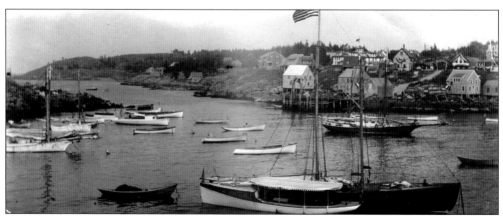

The tercentenary of 1914 on Monhegan Island was celebrated in grand style. Here the harbor is filled with graceful schooners and various fishing vessels. Visitors are surely here to attend festivities, which were held beside the schoolhouse. The villagers decorated homes, boats, and shops with huge flags and banners.

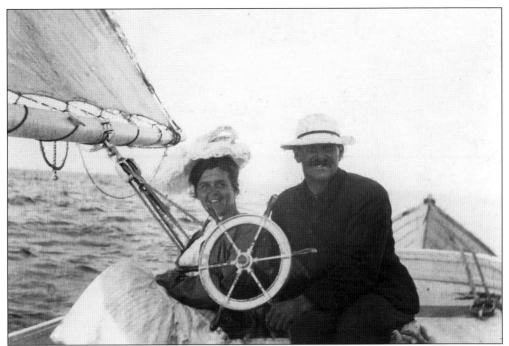

Clearly the harbor and surrounding waters were not just used for fishing purposes. Dolly Underhill and Walter Davis obviously are enjoying sailing about the island on Walter's sloop, the *Leslie and Alice*, probably in 1905. Note the very formal attire; perhaps they are heading to Boothbay Harbor for some social event.

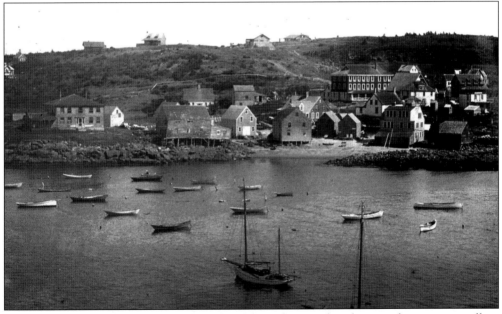

Continuing along the shoreline to the right of the Influence, this photograph gives an excellent view of the Fish Beach area, including the fish houses of the local fishermen hugging the beach. The large many-windowed building in the background is the new Monhegan House. (Cynthia Hagar Krusell.)

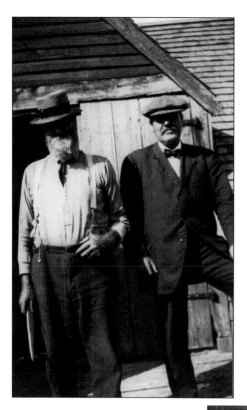

Frank and Alonzo Pierce (around 1900) are standing outside one of the fish houses built by Alonzo. He then built one in 1873 and, with Claudin Winchenbach and a man named Frederick Hodgkins, built another fish house in 1897. The fish houses stored gear, provided space for cutting the fish, and probably saw many a poker game.

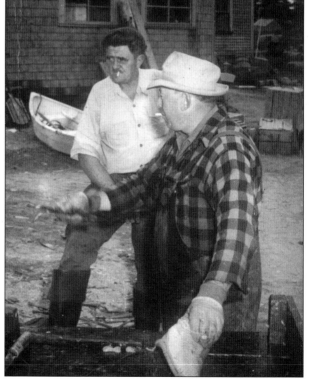

Dwight Stanley and Maynard Orne, perhaps in front of a fish house most likely owned by lobsterman Dwight Stanley, confer on some island matter (around 1950). Dwight grew up on the island. His son and grandson, both fishermen, live on the island today. Maynard was an expert carpenter and a descendant of one of the original Horn settlers.

Not every house gets a chance to hop a boat to Monhegan. This home came over on a barge from Boothbay Harbor about 1919. Cass Brackett had carefully watched the weather and gauged the conditions to make this voyage. The house came in past the old dock and was hauled up on Fish Beach, where it stands today and is owned by a descendant of Brackett. (Cynthia Hagar Krusell.)

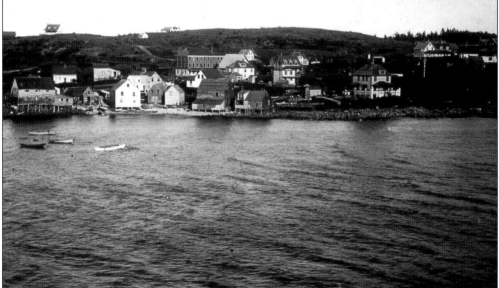

Here is another view of the Fish Beach area. The large home on the right, known as Harbor Spruces, was built in 1898 by Boston artist Eric Hudson. In 1897, he sailed into Monhegan harbor and fell in love with the island. The home remained in the family with his two daughters until 2001. Julie Hudson was rare book librarian at Princeton University. Following in her father's footsteps, Jacqueline (Jackie) Hudson became a very well-known artist with a studio in the house and a studio at Calf Cove. (Cynthia Hagar Krusell.)

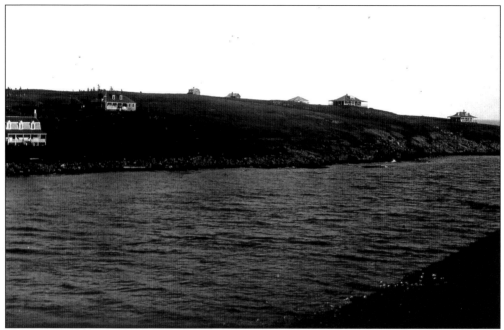

This wonderful early photograph shows the shoreline toward the south end of the island, and Lobster Cove reveals how bare and open the land was years ago. Cottagers and homeowners had clear views to the ocean in many directions. The two houses on the left were built around the beginning of the 20th century by William Stanley and were two of the early summer homes. (Cynthia Hagar Krusell.)

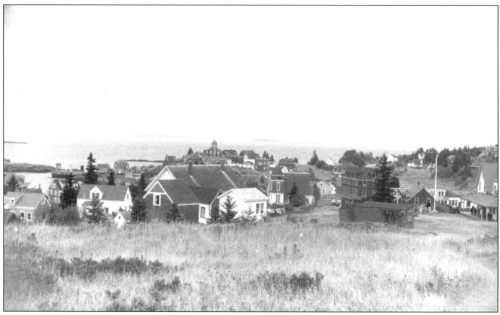

This panorama view from a photograph by Peter Sloat is looking down from the present Trailing Yew, a summer boardinghouse that opened in 1926. The church is in the center, and the Monhegan House is just to the right of the church. The trees are still low enough to permit a long view to the Atlantic Ocean.

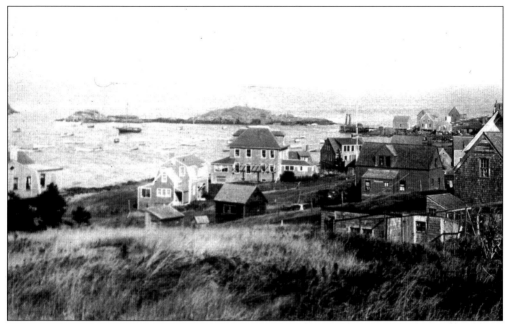

The south end of the main village has a good view of the harbor, the wharf, and the small island of Smutty Nose, which offers some protection for the harbor. The large home on the harbor in the center is Harbor Spruces built by Eric Hudson. To the left of it is the summer cottage of the artists Charles and Mary Ebert, built in 1914. (Cynthia Hagar Krusell.)

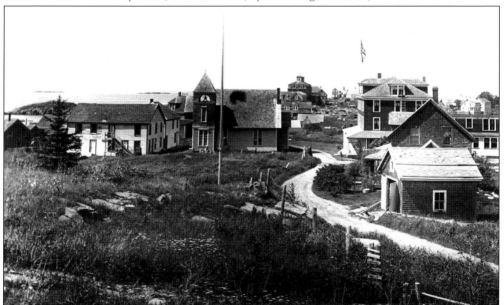

Such open vistas provide this excellent view of the Monhegan Church, erected in 1880 under the supervision of the Reverend B. C. Wentworth of the Methodist Episcopal Church in Boothbay Harbor. The church has long been served by the Sea Coast Mission and summer visiting clergy. The dance hall is on the left and was torn down in 1950. The parsonage (the Makarov Cottage) is now on this property across from the church. The current Monhegan House is on the right of the church, and the Island Inn is in the distance.

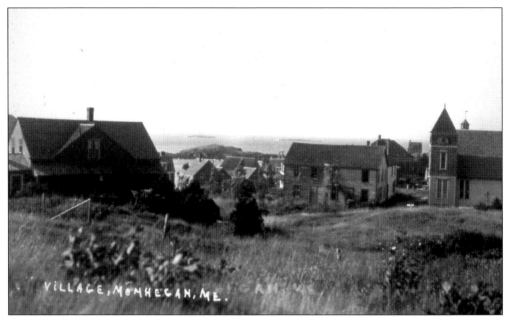

This is a closer view of the church on the right and the long-gone dance hall. The building certainly looks large enough to have some boisterous fun, not only for evenings of dance but for all manner of parties. The admission was 25¢. The house on the left was part of the original Horn property and owned by William Studley. (Cynthia Hagar Krusell.)

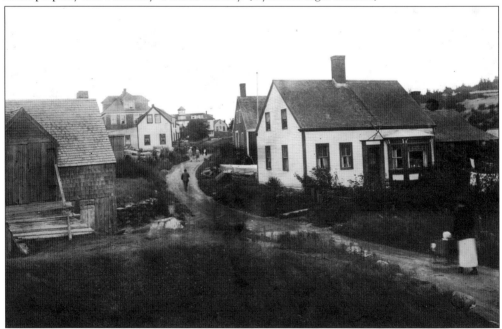

The main village road, seen here around 1920, has always been well traveled by everyone and everything. The woman pushing the carriage will pass the George Trefethren house on the right, one of the older homes on the island, built about 1822. In the distance on the left is the now-pink Carina House. This was built in 1919 by George Brackett to be the post office run by his daughter Elva Brackett. Perhaps the people on the road are off to pick up their mail.

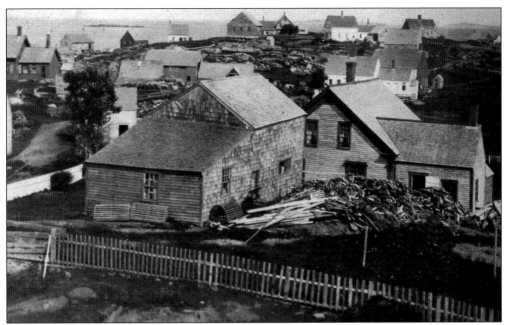

A lot of open space in the village allows for long-distance views to the harbor. Lobster traps and lumber give evidence of a working village not a tourist community. (Cynthia Hagar Krusell.)

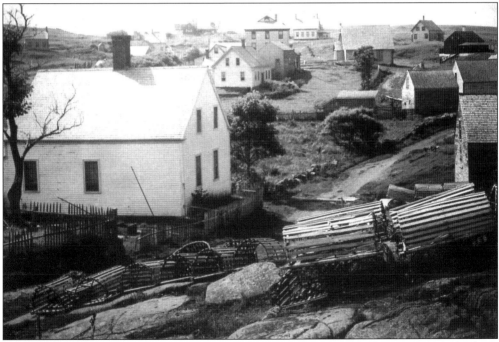

Here is the village road, looking back toward the church and the Monhegan House. The large house on the left, across from the middle beach area known as Swim Beach, is another Trefethren house built by George, a son of Henry Trefethren. George had 11 children and eventually moved into the house known as the Influence on the harbor. Many of George's children remained on the island, married, and moved into other homes. (Cynthia Hagar Krusell.)

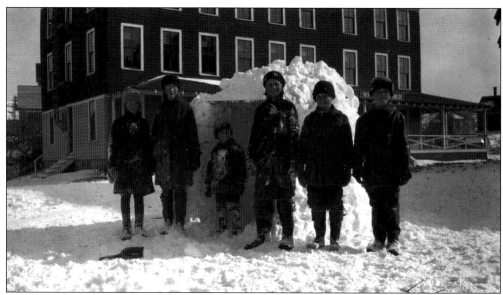

These island children are outside the new Monhegan House in the winter of 1930 or 1931. Elsie Brackett, Beatrice Hutchins, Sherman Stanley Sr., June Brackett, Alfred Stanley, and Clinton Brackett are posing in front of their fort. There is enough snow to build such a structure, which is not always the case, as there is usually more ice than snow on the island.

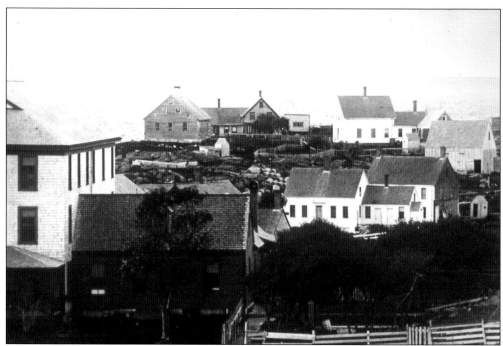

Here in the main village of Monhegan can be seen some of the oldest buildings on the island as well as pasture land and boundary stone walls. In the foreground at the left is the old Albee House, which has been enlarged and is the current Monhegan House. Sarah Albee was the first islander to take in guests beginning in 1870. The so-called Pink House, the cape on the knoll in the middle distance, is the present site of the Island Inn. (Cynthia Hagar Krusell.)

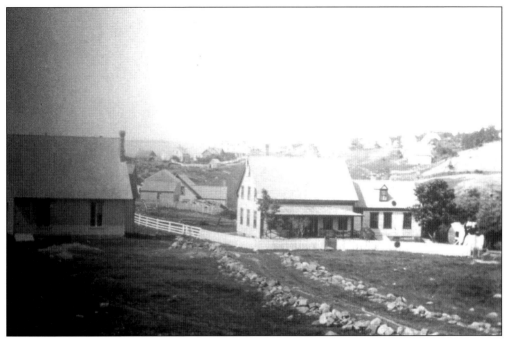

The Albee House was probably a building on the Horn farm as far back as 1843. In 1888, Sarah Albee bought the building and began additions to accommodate visitors. This building became known as the Monhegan House and was run for many years by Elva Brackett Nicolson. With its kerosene lamps and inviting fireplace, this was a favorite place to stay for many visitors. Today this hotel is called the new Monhegan House. (Cynthia Hagar Krusell.)

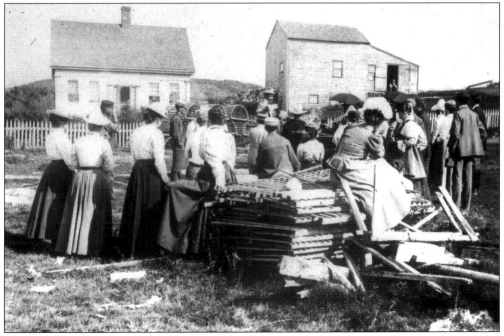

What are these well-dressed women and men watching? Is it possibly an auction? Or is it perhaps a speech or some unusual event? This gathering is right on the main road. (Cynthia Hagar Krusell.)

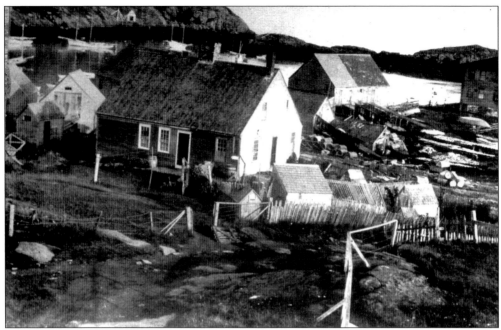

Lobster traps, lumber, and fences are all evidence of a working village. On Manana, the small island across the harbor, the U.S. Coast Guard tramway is clearly visible. (Cynthia Hagar Krusell.)

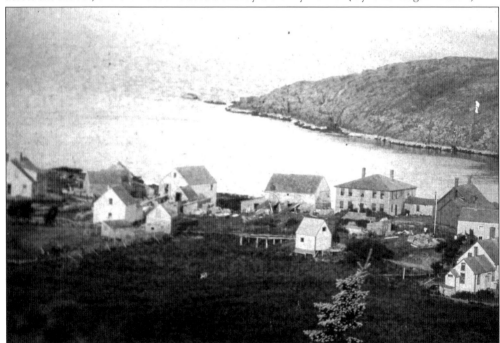

From Lighthouse Hill, there is a sweeping view of the meadow, the village, and the southern tip of Manana Island in the distance. The large square house slightly to the right is the Influence. The house was originally built as a two-family home by Henry Trefethren in 1826, and it took 19 barges to bring lumber for the building into the harbor. Gatherings here were for playing cards and possibly imbibing; thus it was considered to be a bad influence by some residents. (Cynthia Hagar Krusell.)

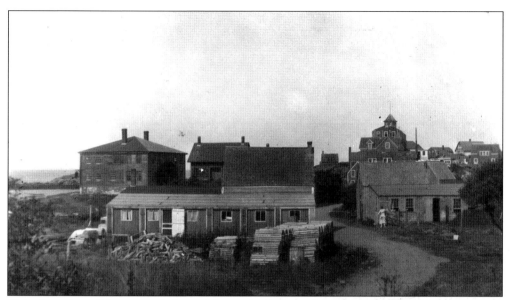

This clear view of the square Influence shows the Roberts Store in the foreground. It is the long low-lying building. Around 1878, Mr. and Mrs. Roberts began supplying the island with needed goods such as fruit, flour, and sugar and provided a place for men to gather to whittle buoys and the like. George Cazallis had an ice-cream parlor attached to this building.

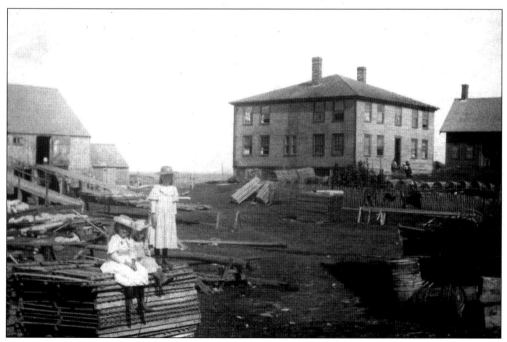

Here is another very open, stark view of the Influence, an easy focal point for visitors to the island. The westerly side was for Trefethren's third wife and the easterly side for his son. Some changes have been added, such as decks and a kitchen on the easterly side. One wonders what the three girls are doing all dressed up.

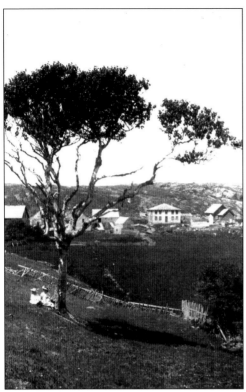

This picturesque tree graces an open hillside, overlooking the meadow and the buildings on the main road. Manana Island is the rocky island in the background. (Cynthia Hagar Krusell.)

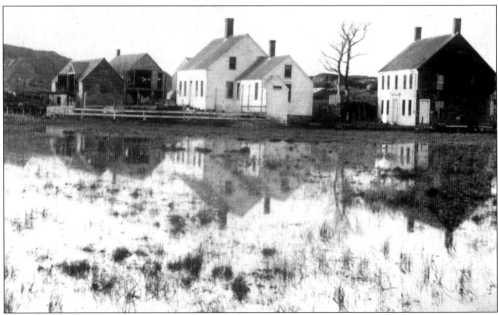

The water-filled meadow reflects the 1784 House, on the right, and the George Trefethren house (1822) in the center. The water from the meadow is the current water supply for the island residents and is pumped out and held in two holding tanks on Lighthouse Hill. As a sole source aquifer, the meadow must be protected for future generations of island residents. A few homes do have cisterns, which accumulate rainwater for use, and a few have wells. (Cynthia Hagar Krusell.)

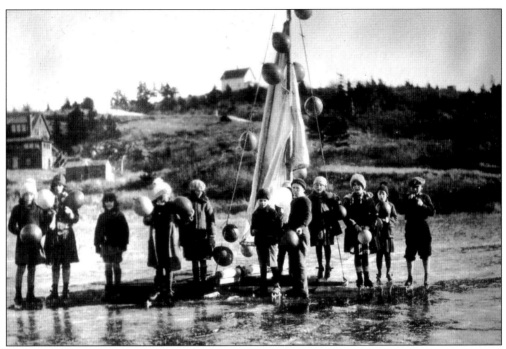

Monhegan children with their iceboat are enjoying the meadow pond in winter. Winter can be difficult for island residents, as there is often cold wind and ice. But ice-skating is very popular, and perhaps these children are here for a birthday party; note the balloons. (Cynthia Hagar Krusell.)

More recreation is available on a very water-filled meadow. The lighthouse and keepers' buildings are visible on the hill. The large dark house on the right was the home of Linwood Davis, who lived all his life on the island and was active in town affairs. His daughter Rita Davis White (1913–2007) also lived all her life on the island and was a much-beloved figure, often seen playing cribbage, washing and hanging out the Island Inn sheets, knitting mittens, tending the store in winter, or watching visitors climb Wharf Hill in front of her home, the John Sterling House. (Cynthia Hagar Krusell.)

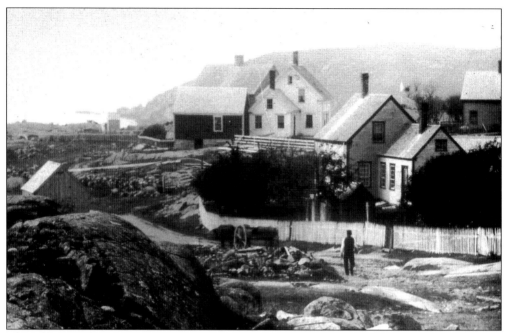

The village road curves to the right between the houses to the wharf. The all-white house in the center was built in 1847, but recent residents remember this as the site of the post office from 1963 to 1982 when Winnie Burton was postmistress. Everyone would gather outside to await the sorting of the mail, a time to socialize and gossip. (Cynthia Hagar Krusell.)

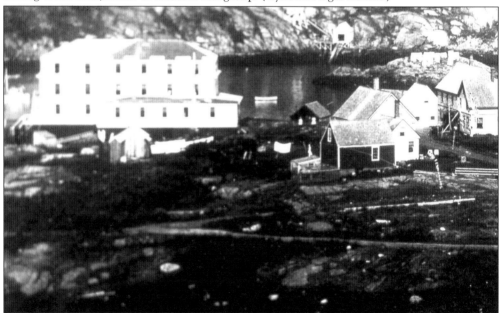

This is a great view of the back side of the Island Inn. The inn has been a popular place for visitors to stay and eat since Frank Pierce bought the property in 1906 and made additions, including a dining room. On the far right is the John Sterling House where Rita Davis White lived for 57 years. White could see the mail boats, passenger ferries, barges, and schooners arriving and departing. The U.S. Coast Guard tramway clearly shows on Manana across the harbor. (Cynthia Hagar Krusell.)

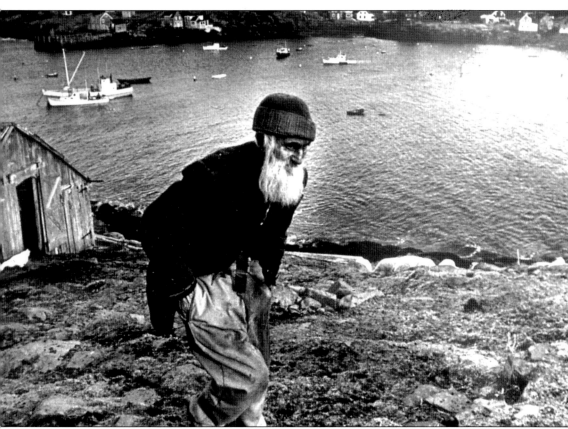

Ray Phillips, a self-proclaimed hermit, lived for 45 years (1930–1974) across the harbor on the small sister island of Manana. He enjoyed visiting with yachtsmen and others who stopped on Manana. Phillips would also row across to Monhegan for occasional supplies. The personnel from the Manana Fog Signal Station, run by the U.S. Coast Guard, would keep an eye open for any problems. Phillips would keep a light burning so that Monhegan residents knew that he was okay. (Cynthia Hagar Krusell.)

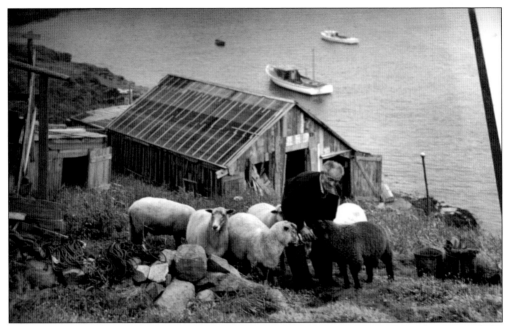

This photograph by Yolla Niclas shows Ray Phillips with his sheep. Phillips briefly attended the University of Maine and served in the U.S. Army during World War I. As a fisherman, he settled on Manana, away from the rush of the mainland. In addition to collecting Social Security, Phillips earned some income from shearing sheep. His shack was built of pieces of driftwood. Many stories exist about Phillips and his unusual mode of living, but the Monhegan community always kept a watchful eye out for his well-being.

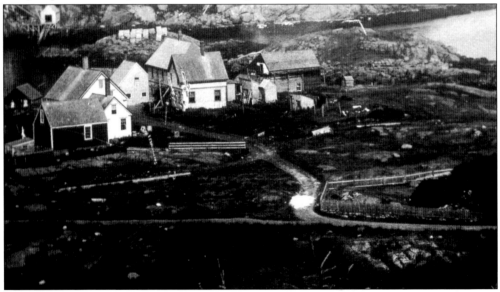

At one time, the road to the wharf was through open land lined by fences and stone walls. The tallest building, the John Sterling House, has sheds behind it, possibly for sheep or storage. The small white building just to the left of the John Sterling House is known as "Uncle Henry's," the name deriving from when Henry Shaw sold produce and milk there in the 1920s. John Sterling built this small house in 1809 for cisterns to provide water for his family. (Cynthia Hagar Krusell.)

A lifelong island resident, Linwood Davis did everything including being a town official, caring for the roads, and repairing the wharf. He is seen here around 1925 with his two daughters, Rita on the left and Lila on the right. A much-beloved resident, Rita died in 2007 having spent her whole life on the island. Her sister Lila is still alive and lived in Florida in 2008.

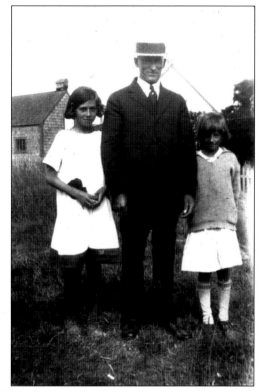

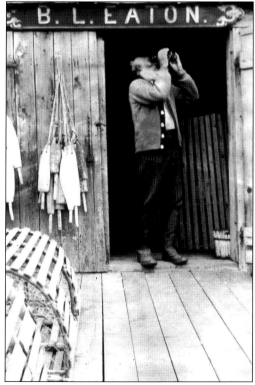

Henry Shaw could keep his eye on the comings and goings up Wharf Hill from the doorway of Uncle Henry's. A pair of binoculars was always readily available. The house was used in later years as a residence and summer rental. (Cynthia Hagar Krusell.)

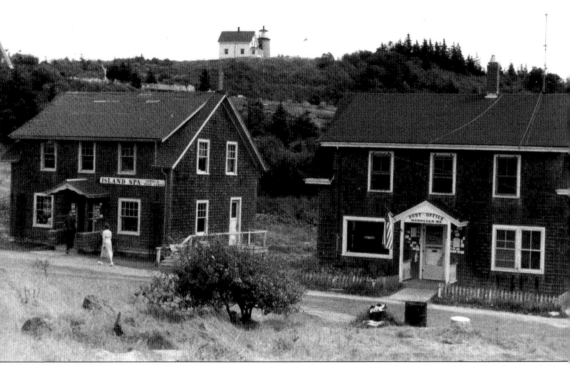

The Monhegan Land Company, a property management company formed in 1908, sold this land to Lorimer "Zimmie" Brackett, who built the famous Island Spa, the building on the left. The spa was a gift shop where just about anything could be found, from penny candy to shoes to paint to the *New York Times* and used cribbage boards. Zimmie was a wonderful and special island resident, an accomplished dancer, and an avid bridge player. The Monhegan Land Company sold the land to Elva Brackett, who built the structure on the right, which housed the post office for many years. There were special restrictions on both of these buildings, such as they could be used as blacksmith shops, all waste had to go into a septic system, and the properties had to be maintained in neat and orderly manners.

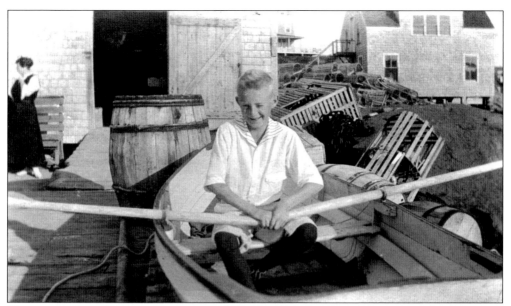

This is an image of a young Zimmie in a skiff around 1915. Most residents remember him many years later standing behind the counter at the spa with his flowing white hair. His coffee, brewed in a battered coffee pot, was also well known.

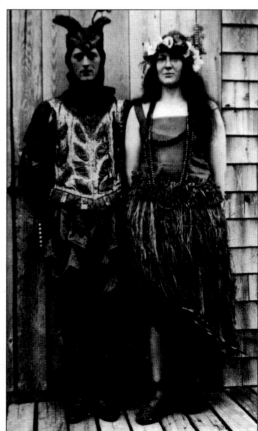

Zimmie loved to participate in island celebrations, parties, or whatever. Here in 1925, he is with Josephine Townshend in costume, perhaps for a special island theatrical event.

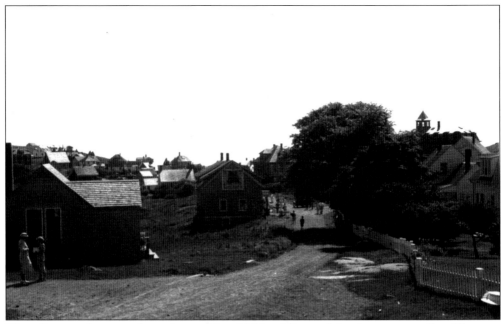

The village road turns right in front of the old Island Spa and the former post office. They are the two buildings beside each other with the chimneys in the center. The Monhegan Memorial Library, built in 1930, is the building on the left. Perhaps the two ladies have just borrowed some books. The large tree on the right in front of the Shining Sails, so named by the Nunan sisters in 1908, is still there today.

TRAILING
YEW

A Story of Monhegan
by
Patience Stapleton

1921
Hudson Printing Co.
Boston

This is one of the intriguing books in the Monhegan Memorial Library. The author, Patience Stapleton, who was born in Wiscasset, Maine, tells a fictional story of fishermen and their families on the island. The main section of the Monhegan library was built in 1930, to honor the tragic drowning of two children in 1928, and named the Jackie Barstow and Edward Vaughan Memorial Library. (Margot Sullivan.)

Monhegan Press

Vol. 1, No. 13 Monhegan, Maine Sat. Sept. 3, 1938 Price Five Cents

FIRE PURCHASE FUND REACHES $210 TOTAL AFTER ART EXHIBITS

--

Accounting Shows Large Sum for Acquisition By Plantation

--

ART PORTFOLIO DROPPED

--

Drive Ends as Interest Lags in Proposal To Complete Fund

--

Monhegan's fund for acquisition of modern fire equipment had reached a $210 total today after an accounting of proceeds from recent art exhibits.

This figure represented half of the sum needed for purchase of the type of apparatus envisioned by leaders in the drive to provide adequate protection on the island.

Meanwhile the drive itself was brought to an end by dropping of a plan to complete the fund through issuance of a portfolio of art by Monhegan artists.

Jay Connaway, sponsor of the idea, attributed this step to lack of interest.

Final accounting of funds show the fol-

(Turn to Page 5)
---x---

CIRCUS NETS $254 FOR LIBRARY FUND

--

Final accounting of Monhegan circus proceeds this week placed the total at $254.16, Miss Ethel Howland, chairman, announced. This amount which

Aids Growth Here --An Island Portrait--

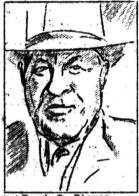

Frank C. Pierce

FRANK PIERCE FELLED OWN TIMBER TO BUILD FIRST MONHEGAN DOCK

Former Hotel Owner Has Aided Island Growth In Many Ways

--

Visitors to Monhegan this year have missed one activity which they had come to regard as an inseparable phase of the island's life.

This is the former one-man fishing expeditions of Frank C. Pierce, genial hotel man who formerly owned and operated the Island Inn.

Until sickness forced him to give up his favorite hobby, Mr. Pierce made daily

--

(Turn to Page 4)
---x---

800 GUESTS LISTED
IN LIGHTHOUSE LOG

MONHEGAN LIBRARY TO EFFECT CHANGE IN PUBLIC STATUS

--

Group Will Incorporate At Annual Meeting Here Today

--

EIGHT TRUSTEES NAMED

--

Action Will Not Change Present Management Board Says

--

Giving the institution a permanent public status, the Monhegan Library was to be incorporated today at the regular annual meeting of the sponsoring association.

The session was scheduled to begin at 9 o'clock in the library building, with Cyril A. Nelson, President, in charge.

While no visible change in the present management will result from the action, board members have announced that they deem the step advisable.

Incorporation will be effected under the Revised Statutes of Maine.

It will change the library group from a voluntary association, which it has been during the 12 years of its operation, to a literary institution.

Incorporators under the action will be:

Elizabeth W. Dun-

(Turn to Page 3)
---x---

ROBERT DUNCAN WINS TENNIS CLUB TOURNEY

The Monhegan Memorial Library houses a collection of Monheganiana including copies of the *Monhegan Press*. Over the years, various residents have produced island newsletters or newspapers. The *Monhegan Press* in the late 1930s provided local news, comings and goings of winter and summer residents, advertising, political news, and important information such as the tide charts. Eagerly awaited issues sometimes had sketches of local residents by local artists. (Margot Sullivan.)

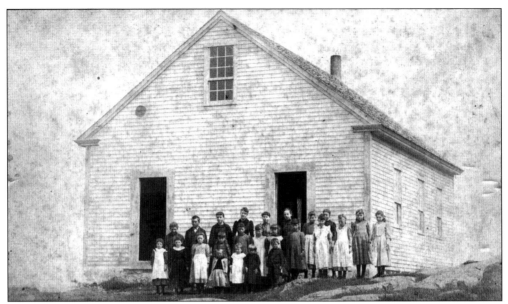

In 1848, Monhegan Plantation voted to start a "female" school and "man" school, officially providing a public school on the island. This photograph, from around 1892, shows the one-room schoolhouse with a large enrollment of more than 20 students. In spite of dramatic declines in student population in recent years, the school has been in continuous operation ever since.

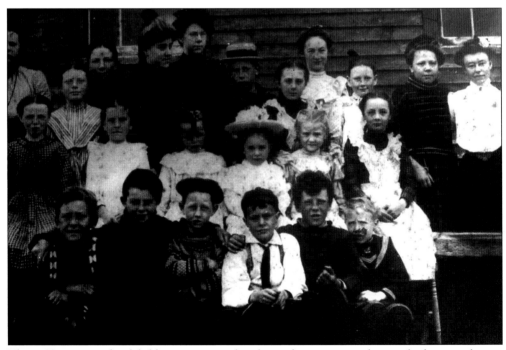

These 22 serious schoolchildren were proud to have their picture taken with their teacher in front of the one-room schoolhouse. Many of them are direct descendants of the original settlers, especially the Trefethrens and the Starlings. The grades run from kindergarten through grade eight. The students then go to high school on the mainland. (Cynthia Hagar Krusell.)

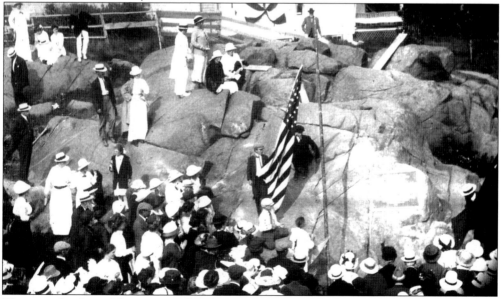

CAPTAIN JOHN SMITH
ADVENTURER IN MANY OLD WORLD COUNTRIES
A PIONEER IN THE NEW WORLD
GOVERNOR OF VIRGINIA
CAME HERE WITH TWO VESSELS IN 1614
ANCHORED IN THIS ISLAND HARBOR
AND EXPLORED THE COAST FROM PENOBSCOT BAY TO CAPE COD
DISCOVERING A LARGE OPPORTUNITY
FOR ADDING TO ENGLAND'S GLORY BY COLONIZATION
HE RETURNED HOME AND SPENT HIS REMAINING YEARS
IN ADVANCING AMERICAN ENTERPRISES
BECAUSE OF HIS GREAT INTEREST IN THE FUTURE OF AMERICA
AND TO COMMEMORATE HIS CONNECTION WITH THIS ISLAND
THIS TERCENTENARY TABLET IS PLACED
BY MONHEGAN RESIDENTS
1914

Next to the schoolhouse, and a focal point for visitors, is this plaque mounted on a boulder. Capt. John Smith visited the island in 1614. Earlier explorers and fishermen had discovered the island, but Monhegan residents felt Smith's visit deserved a memorial. The tercentenary of the landing of Smith was celebrated in 1914 with the mounting of this plaque. Smith spent some time on the island and produced a map of the New England coast clearly showing Monhegan as Barty Island. (Cynthia Hagar Krusell.)

The cause for this celebration was the 1914 tercentenary of the landing of Smith on the island. Island residents are here witnessing the unveiling of the plaque. Another earlier famous visitor and explorer often mentioned is Capt. George Weymouth, who stopped on the island in May 1605. (Cynthia Hagar Krusell.)

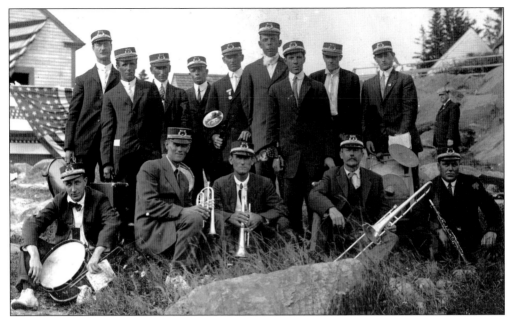

Monhegan even produced a band for the tercentenary celebration on August 6, 1914. The band included carpenters, artists, fishermen, and winter and summer residents. Seen here are, from left to right, (first row) George Bellows, Ulysses Wallace, Will Stanley, George Green, and Otis Thompson; (second row) Elsworth Wallace, Earl Field, Linwood Davis, Charlie Field, Maynard Brackett, George Smith, Ed Brackett, Dexter Richards, and Dick Stanley. Standing in the right background is Edwin Jenney.

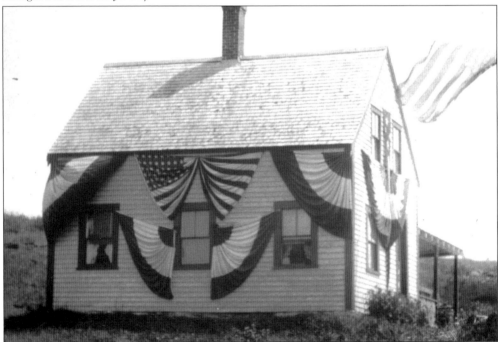

A local resident's home is well decorated for the tercentenary celebration in 1914. (Cynthia Hagar Krusell.)

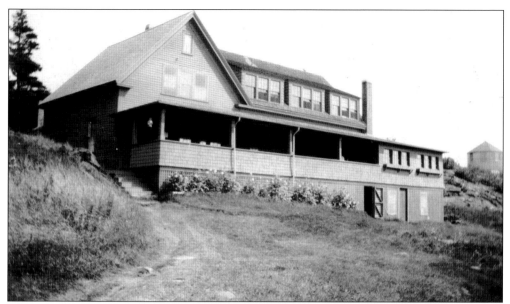

This imposing residence known as Tribler Cottage was partially built in 1820 by Solomon Genthner to be used as a home. The sisters Angeline and Isabel Tribler purchased the property in 1908, enlarged the building, and added the porch. At that time, the sisters became owners of the Island Inn, and this Tribler Cottage provided an annex of rooms for the inn. Tribler Cottage continues today providing housekeeping unit lodging and is operated by Richard Farrell, the grandson of Angeline Tribler.

This road probably leads to the back side cliffs. The trails and paths are often in the open, as this one is, or they wind through dense forest passages out to spectacular views of the Atlantic Ocean. (Cynthia Hagar Krusell.)

Ted Edison, the son of Thomas Alva Edison, visited Monhegan as a young boy in 1908. After he was married, he and his wife, Ann, began to purchase land on the back side of the island from the 1930s on. In 1954, Ted, with 10 other island landowners, formed Monhegan Associates, to hold in perpetuity all of the wild lands that he purchased, as well as to create bylaws for future purchase, maintenance, and governance of the organization. If it were not for Ted's foresight, the property on the back side of the island leading to the towering magnificent cliffs would probably be residentially developed.

CONFORMED COPY OF THE
CERTIFICATE OF ORGANIZATION
OF
MONHEGAN ASSOCIATES, INC.

State of Maine

Certificate of Organization of a Corporation, under Chapter Fifty of the Revised Statutes, and Amendments thereto

The undersigned, officers of a corporation duly organized at Monhegan Plantation in Monhegan Plantation, State of Maine, on the eighth day of September, A. D. 1954, hereby certify as follows:

1. The name of said corporation is Monhegan Associates, Inc.

2. The purposes of said corporation are:

(a) To preserve for posterity the natural wild beauty, biotic communities, and desirable natural, artificial, and historic features of the so-called "wild-lands" portions of Monhegan Island, Maine, and its environs, as well as the simple, friendly way of life that has existed on Monhegan as a whole.

(b) To collect, collate, maintain, and preserve for posterity, records and archives respecting the flora, fauna, and human inhabitants and sojourners on said island, and to make the same publicly available for educational, literary, scientific, and historical research, study, and consultation.

(c) To take and hold by purchase, gift, devise, bequest, or otherwise, lands and other real property and personal property, to the extent permitted by statute; and to dispose thereof only for the purposes for which this corporation was organized.

(d) To pay voluntarily its fair share of the expenses of Monhegan Plantation, whether or not this corporation shall be legally exempt from taxation.

(e) To use for the charitable support of nature-conservation projects elsewhere, such of this corporation's funds and accumulated net income as may be judged by at least seven-ninths of this corporation's Trustees to be in excess of amounts that should be prudently held in connection with the other stated purposes of this corporation.

(f) To adopt and be governed by by-laws, not inconsistent with law or with the foregoing purposes; which by-laws shall provide for one or more classes of members, the members of which classes shall meet such qualifications and requirements, pay such dues and fees, if any, and have such voting power per member, if any, as shall be specified in the by-laws including amendments thereto; and which by-laws may be amended only in the manner set forth in the original by-laws or in proper amendments thereto.

3. The life of this corporation shall be perpetual.

The 1954 certificate of organization of Monhegan Associates specifies in detail the goals of the organization. Monhegan Associates continues today to protect the wild lands, clear the trails, and research information for forest management. (Margot Sullivan.)

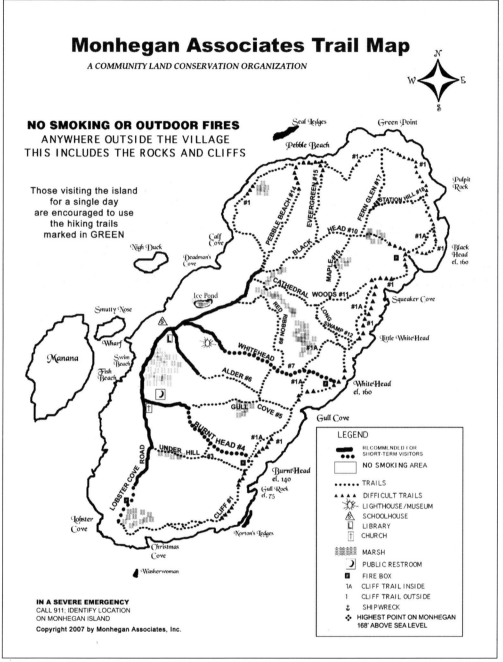

Monhegan Associates Trail Map

A COMMUNITY LAND CONSERVATION ORGANIZATION

NO SMOKING OR OUTDOOR FIRES
ANYWHERE OUTSIDE THE VILLAGE
THIS INCLUDES THE ROCKS AND CLIFFS

Those visiting the island
for a single day
are encouraged to use
the hiking trails
marked in GREEN

LEGEND

RECOMMENDED FOR SHORT-TERM VISITORS

NO SMOKING AREA

..... TRAILS

▲▲▲▲ DIFFICULT TRAILS

☼ LIGHTHOUSE/MUSEUM

Ⓐ SCHOOLHOUSE

Ⓛ LIBRARY

✝ CHURCH

MARSH

☽ PUBLIC RESTROOM

■ FIRE BOX

1A CLIFF TRAIL INSIDE

1 CLIFF TRAIL OUTSIDE

⚓ SHIPWRECK

❖ HIGHEST POINT ON MONHEGAN
168' ABOVE SEA LEVEL

IN A SEVERE EMERGENCY
CALL 911; IDENTIFY LOCATION
ON MONHEGAN ISLAND

Copyright 2007 by Monhegan Associates, Inc.

This Monhegan Associates trail map shows the various trails through the wild lands to the cliffs of Burnt Head, White Head, and Black Head. Donations of land and conservation easements by individuals, as well as purchases by Monhegan Associates, have preserved all of the land shown in the shaded areas on the map. What a wonderful legacy Ted left to Monhegan. (Clare Durst.)

37

THE UMPIRE

HAVE PITY ON THIS PATIENT MAN.
HE DOES THE VERY BEST HE CAN.
WE HOOT, WE GROAN, WE CURSE HIS NAME.
BUT HAVE TO MIND HIM JUST THE SAME

———

BALL GAME TODAY, WEDNES,
4.15

Ball games have always provided recreational fun if not many moments of comic relief for the fishermen, carpenters, hotel workers, and others. This poster by noted artist Frederic Dorr Steele announced an afternoon game. The late actor Zero Mostel was perhaps the player everyone wanted on his team. He flaunted the rules and taunted the players. The laughter was great.

Two

DOWN TO THE SEA

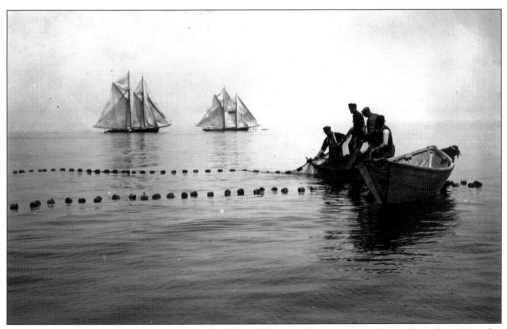

The surrounding sea has provided the livelihood for Monhegan since the earliest days. It is the integral part of life on the island. For many years, seining, or casting nets for collecting large numbers of fish, was a regular part of the fishing business in Maine waters. These men, seining from dories around 1910, will return to the waiting schooners with their catch.

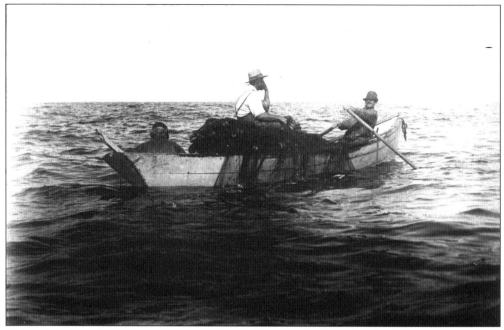

This might be titled "Three Men in a Dory." Here are William Bainbridge Davis, otherwise known as Uncle Ben Davis, on the far left and Walter Davis on the far right. The Davis family has long been associated with Monhegan. Family members were frequently called by familial names, such as uncle, by everyone on the island.

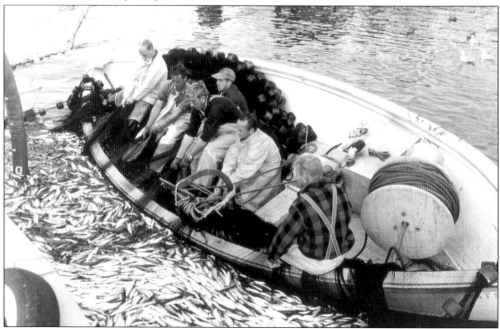

What a catch. This net, probably full of mackerel, is threatening to upset the dory already loaded with fishermen, including Jimmy Barstow, Jimmy White, Don Cundy, Johnnie Field, and Ronnie Stanley. This photograph by Max Rosenthal clearly speaks to the hard work of the island fishermen.

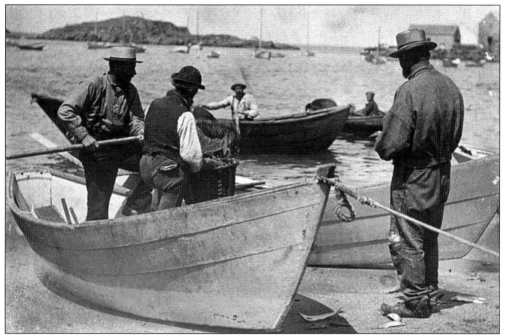

Fish Beach in the heart of Monhegan village is the point of departure for the fishing activities of the island. From dories pulled up on the beach, the fishermen bring in the day's catch. In this dory, Frank Pierce is holding the net while James Breeson unloads the fish. Seen in the distance are the dock and Smutty Nose, a small island in the middle of the harbor.

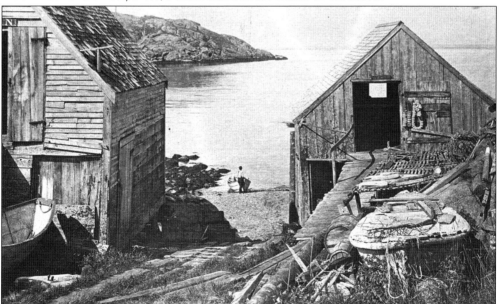

These old fish sheds belonging to the Brackett and Wincapaw fishermen were part of the picturesque quality of the island. Often the subject of an artist's brush, or in this case a photograph by S. P. R. (Samuel Peter Rolt) Triscott, the buildings housed the gear of the fishermen and sometimes the fishermen themselves. Some of the shed lofts have been home to the island's artists. Others have housed a fish market or an eatery now and then.

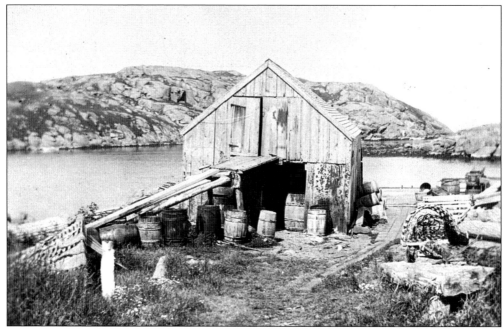

In this try house, later used as a freight shed, the oil from fish and whale livers was "tried," or what is sometimes called "reduced." Manana Island, Monhegan's sister island, looms across the harbor, an important buffer for this open-ended anchorage. The massive presence of Manana Island is always felt on Monhegan.

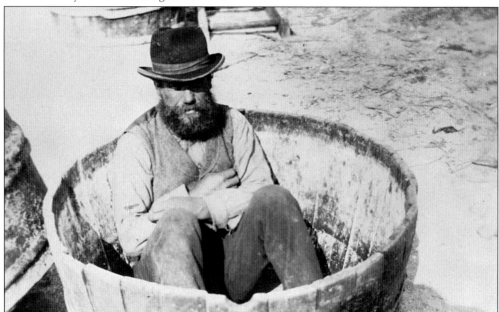

"Rub-a-dub-dub," one man in a tub. Is Len Richards taking a break from the day's work, or is he posing for his picture? Maybe he's thinking about all the old families of Monhegan, such as the Starlings, Trefethrens, and Hornes, who have lived, worked, and played on this magical island at the mouth of Penobscot Bay. James Rosier in 1605 called Monhegan "an island of some six miles in compasse, but I hope the most fortunate ever discovered."

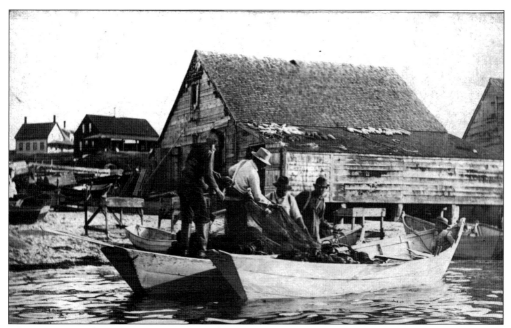

These men in their dories are sorting their nets just off of Fish Beach sometime before 1900. On the far left is Ben Davis, and the man next to him with the white shirt and hat is Frank Brackett. The old fish-drying flakes are visible on the beach, and in the background can be seen Sherm Stanley's house and the Trailing Yew, a landmark inn operated by Josephine Davis from 1926 to the 1990s. There are no trees as there are today, and the fish house is only half as tall as it later became.

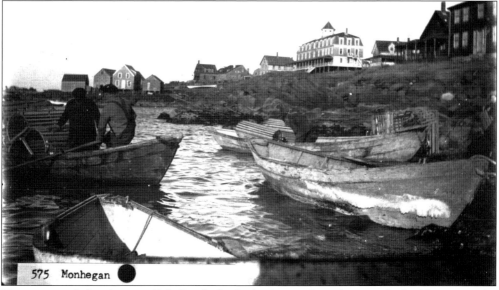

575 Monhegan

Here are trap-laden dories at Fish Beach. In the background can be seen the buildings near the Monhegan dock, the Island Inn and, on the extreme right, the square-Colonial house referred to as the Influence, built in 1826 by Henry Trefethren and his wife, Jemima Starling. Being a place of convivial gatherings where the men indulged in lively poker games known as the work of the devil, the house was seen as a bad influence upon the fishermen.

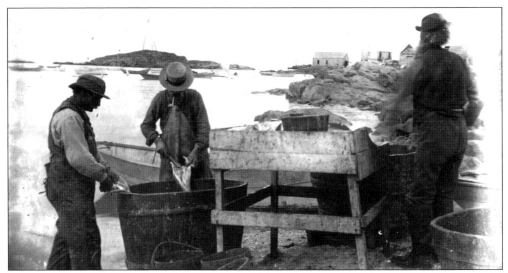

In this photograph by Eric Hudson, Andrew Peterson and William Bainbridge "Uncle Ben" Davis are seen hard at their work of cleaning fish, readying it for the fish-drying flake. Such work was in the long tradition of earlier fishermen who had regularly used Monhegan as a fishing station prior to any permanent settlement in New England.

Here Sherm Stanley (right) is instructing Mattie Thompson in the art of salting cod. One of the Gulf of Maine fishing areas frequently used by Monhegan fishermen is Cashes Bank or Ledge. This rich fishing area is about 74 miles southeast from Cape Elizabeth. It is 22 miles long by 17 miles wide and consists of a number of small shallow shoals over which the water breaks in rough weather. Fishing on these grounds is principally for cod, haddock, hake, and cusk. Cod is most abundant in February, March, and April.

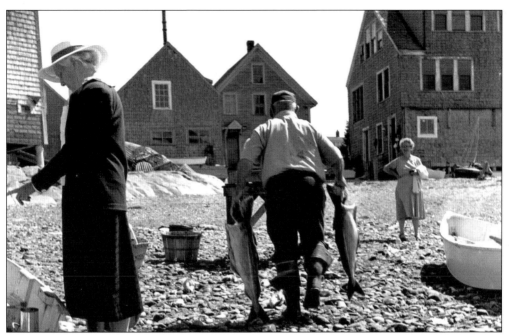

Chris Nicholson is seen here carrying a couple of big fish while Alice Kent Stoddard and Olga Stevens Wolcott stand by. The artist Stoddard on the left may be planning a painting here on Fish Beach. Charles F. Jenney wrote in the *Lewiston Evening Journal* of August 6, 1914, "It is thru these men and women that this tiny isle of the seas has been made familiar to art lovers, at least, the world over."

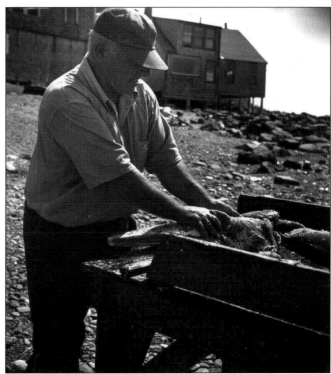

Nicholson is cleaning fish in this photograph by Yolla Niclas. Monhegan today continues to be a working island in the long tradition of fishermen of the sea in the Gulf of Maine.

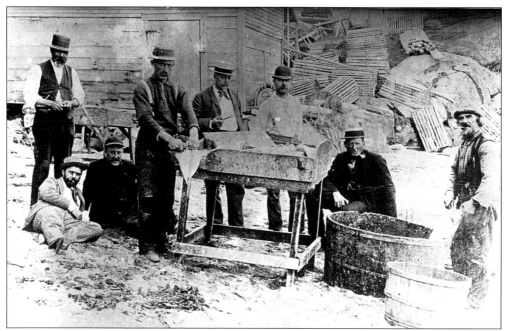

The gang's all here. These eight fishermen of Monhegan would have a lot to tell of their adventures offshore and onshore, of tempests and traps, of boats and barrels, and many a tall fish tale. Here they all have their hats on and are ready to pose for the cameraman. Then it is away to the Influence for a game of poker.

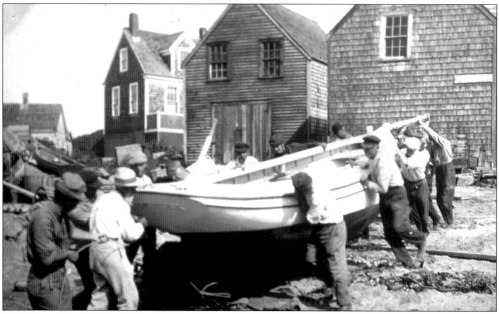

Most of the original families on the island were engaged in fishing and erected their fish houses on this small beach. It has been known ever since as Fish Beach. The first fish houses were built by the Trefethren and Horn fishermen. Seen here are the Claudin Winchenbach (center) and Alonzo Pierce (right) fish houses built in 1897 and 1873 respectively. It took 10 strong Monhegan men to launch this boat from Fish Beach. (Cynthia Hagar Krusell.)

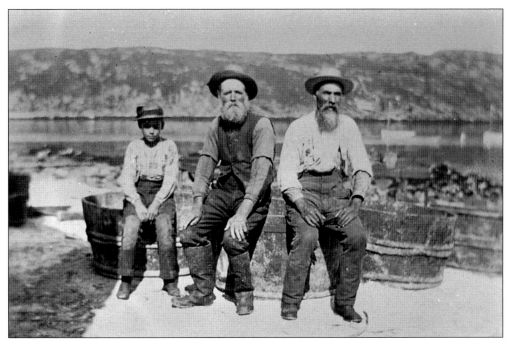

"Rub-a-dub-dub," three men on their tubs. George Humphrey, Rufus Pierce, and Claudin Wincapaw face the camera. As Louise Dickinson Rich said, "Monhegan is really a way of life. The islanders number less than a hundred, but they know how they want to live, and they live that way."

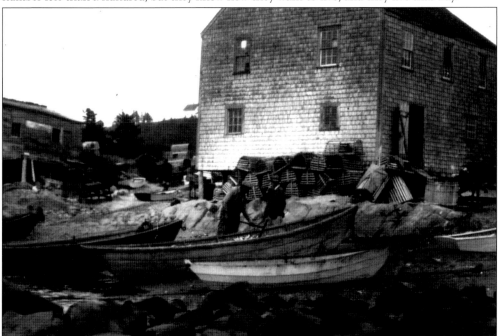

Thomas Horn's fish house was built possibly as early as the 1780s. The Horns were one of the three original families who received a large lot or slice of Monhegan Island in the 1807 division of land. Most of the fish houses have been owned over the years by the old Monhegan families, such as the Trefethrens, Starlings, Horns, Wincapaws, Pierces, and Davises. (Cynthia Hagar Krusell.)

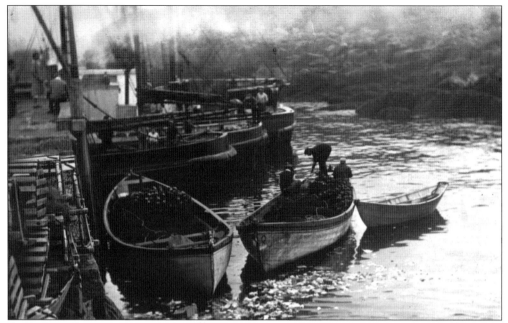

A number of large seining vessels are drawn up at the Monhegan wharf with three support dories in the foreground. For many years, mackerel fishing was done with purse seines. This form of large net fishing was practiced during the era when huge schools of mackerel swam the waters of the Maine coast. The net was hung vertically with floats at the top and sinkers at the bottom. A purse seine had a drawstring to draw the ends together like a purse to encircle the fish.

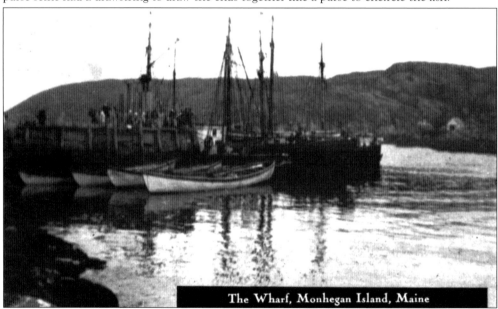

The Wharf, Monhegan Island, Maine

This postcard, titled "The Wharf, Monhegan Island, Maine," shows a scene at the dock about 1946. A public wharf belonging to Monhegan Plantation was built here in 1908. A fleet of seining boats, used in the mackerel fishery, is shown tied up to the wharf along with their support dories ready to load or unload. By 1940, the seining fleet of Monhegan included the steamers *Lewis L.*, *Fox*, *Hattie M. Wetten*, *Florence and Mildred*, *Monhegan*, *Alert*, and the sloop *Defender*.

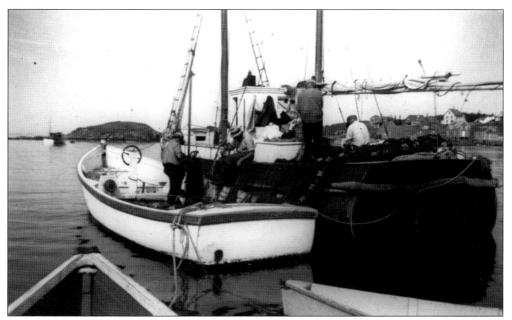

These men on their vessels are mending the seining nets about 1940. Fishing was the mainstay of Monhegan industry from the earliest days when Europeans came seasonally to fish the great schools of cod that inhabited the waters of the North Atlantic. Later it was mackerel fishing or herring and bluebacks that attracted fishermen to the island.

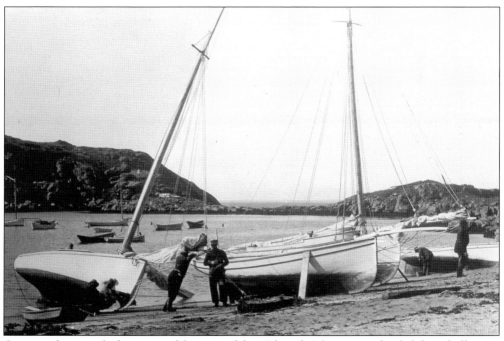

Once, explorers and adventurous fishermen of the 16th and 17th centuries hauled their shallops up this small stretch of sandy shore at Monhegan harbor. It was here that ships, fish-laden with a rich catch from the Gulf of Maine, departed for Spanish or Portuguese ports. These sturdy catboats on the beach are of a later era when fishing became a local endeavor. (Cynthia Hagar Krusell.)

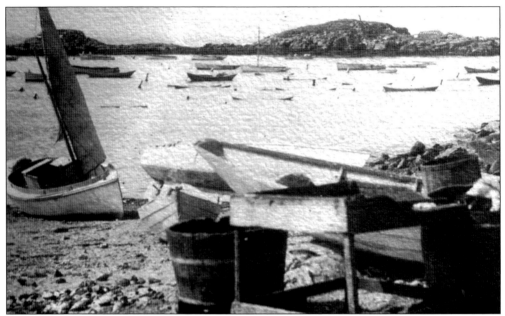

This picture was probably taken about 1900. Note the fleet of small boats and dories in the harbor. Has the era of larger lobster boats not yet arrived? Or are the owners of the boats out hauling their traps, having left their dories on the moorings? The old flake and the barrels await their catch. (Cynthia Hagar Krusell.)

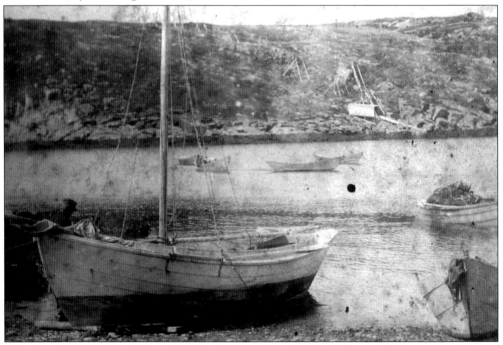

This appears to be a sloop-rigged dory hauled up on Fish Beach. Having both a mainsail and a jib, it is maneuverable and easy to bring in to the wind or jibe about when chasing down a school of mackerel. Manana looms across the harbor, and the old equipment for the Manana Coast Guard station can be seen in the distant right. (Cynthia Hagar Krusell.)

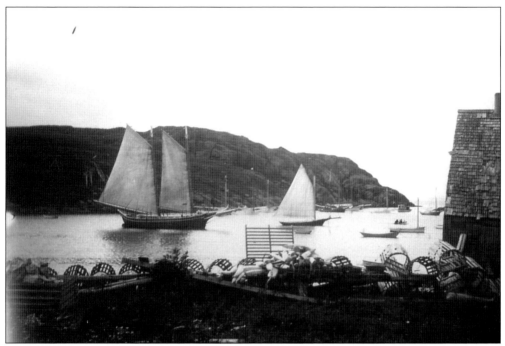

A wonderful row of old wooden lobster traps forms a suitable foreground for this picture of a grand gaff-rigged schooner and a small friendship sloop. Both of these vessels probably were made in Maine at one of the shipbuilding sites on the mainland. Although shipbuilding was done on Monhegan, these are classic Maine-built craft associated with the larger yards at Bath or Boothbay Harbor. (Cynthia Hagar Krusell.)

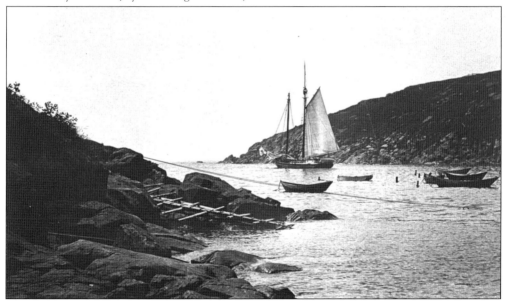

A tall schooner heads out the south end of Monhegan harbor. The harbor is open at both the north and south ends and is known as a roll-hole to yachtsmen cruising the area. Notice the line of the pulley system that runs out from the shore. This is a photograph by S. P. R. Triscott, one of the first artists to do extensive photography on Monhegan.

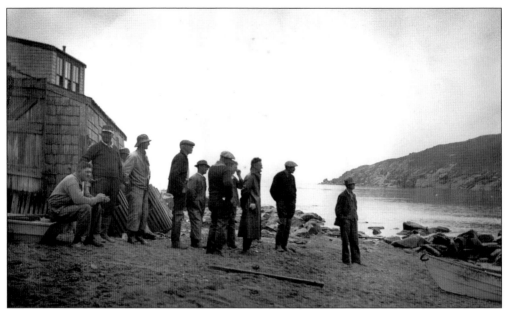

These men are intently watching the launching of the *Phyllis L.* Shipbuilding on Monhegan started with John Smith in 1614. In the account of his voyage, he mentioned that while he explored the coast others of his crew stayed on the island to fish "using seven boats which they constructed on the island." In the early 19th century, Josiah Starling was said to have built vessels on the site of the freight shed.

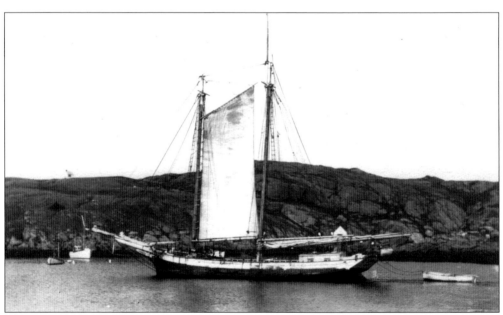

This W. H. Ballard postcard is titled "A Coaster, Monhegan, Maine." It shows the harbor as it looked about 1900. This big, old wooden-hulled schooner is quite a presence in the harbor with Manana as a backdrop. Today some of the old vessels, now known as windjammers, cruise to Monhegan from Camden or Boothbay Harbor bearing summer vacationers who spend a week or two experiencing life onboard ship.

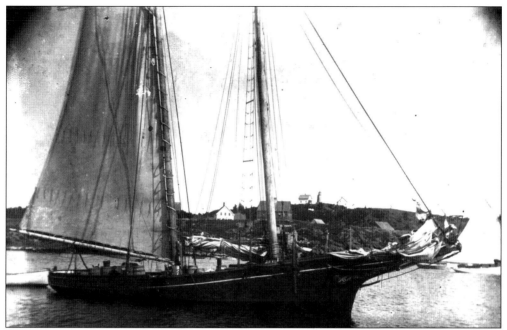

Well-known Monhegan artist and photographer Eric Hudson took this picture of an old fishing schooner in Monhegan harbor about 1880. Such schooners were merchant ships carrying cargos of fish, supplies, and lumber up and down the Maine coast. Their visits to this island 10 miles off the Maine coast were anticipated with much eagerness by the islanders.

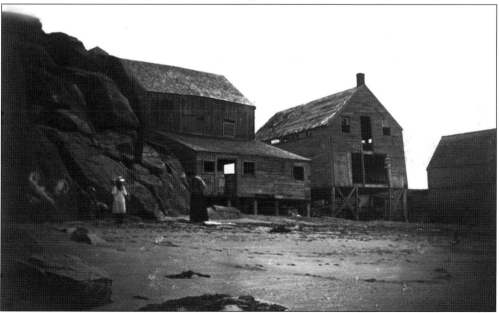

These old fish houses at the so-called bathing beach, now called Swim Beach, were photographed by E. T. Knowlton in 1897. Samuel Adams Drake wrote of the Monhegan beach in 1891 that "The beach itself is formed of about equal parts of sand, shells and fish bones. One man ventured the assertion that if all the fish bones that had been thrown into the harbor could be gathered together into one heap, they would reach as high as Monanis [Manana]."

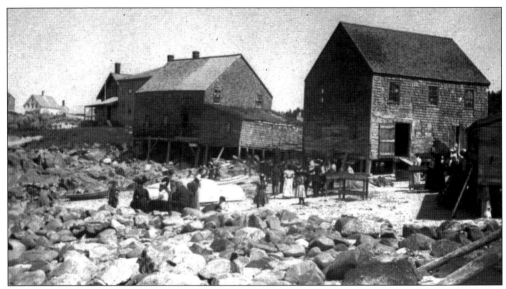

It would be fun to go back to 1900 and join this party on the beach. Perhaps they are having a fish fry or a lobster bake in celebration of someone's birthday, or is it the Fourth of July? Note the women all dressed up with hats on and long dresses and skirts. The scene would be quite different today. (Cynthia Hagar Krusell.)

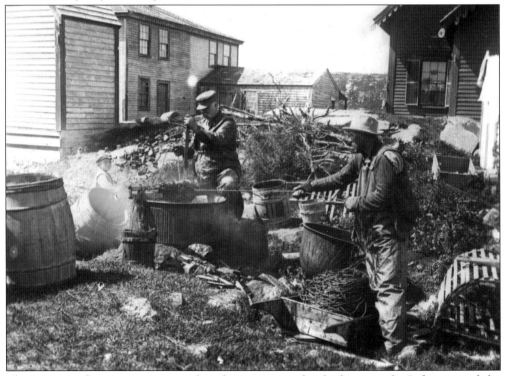

These men are busy tarring rope in these large steaming kettles between the Influence and the red house. Note the small boy watching them and how many barrels and old wooden lobster traps there are. Tarring rope was part of the work of Monhegan, along with making lobster traps, mending nets, repairing and painting boats, and setting moorings.

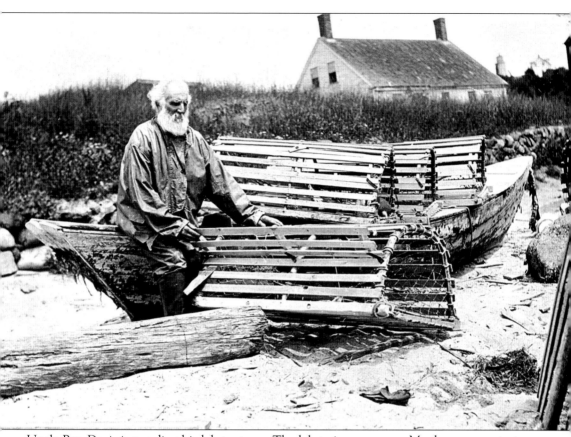

Uncle Ben Davis is mending his lobster traps. The lobstering season on Monhegan now starts October 1, although for many years it started on January 1. On a certain day determined by the lobstermen, everyone leaves the harbor together at an appointed time to set their traps. In this way, all the men get an equal chance to lobster in the most desirable places. The day is known as Trap Day. At the end of the lobster season toward the end of May, the men pull their traps at different times. No lobstering is done during the summer months when the lobsters migrate inland to warmer waters.

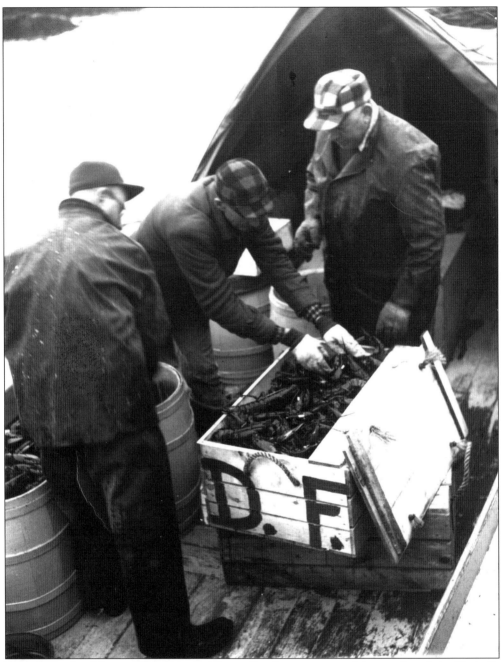

Dwight Stanley, Maynard Brackett, and Banes Stanley are sorting lobsters aboard the *Freda B.* about 1950. Of all the fishing activities on Monhegan, lobstering is the best known. Perhaps this is due to the excitement and popularity of Trap Day, a day of great celebration on this island far out in the Gulf of Maine.

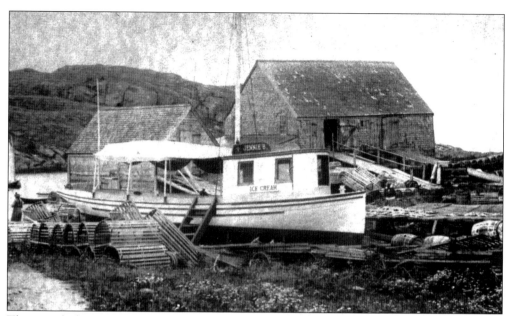

This vessel, the *Jennie B*, is high and dry with a canopy over her deck and a sign that says "Ice cream." This seems strange indeed for a hardy vessel of the rough Monhegan waters. It is not a joke, however, for Jennie Starling (later Whibley) ran a tearoom in this boat in her yard about 1912 when this photograph was taken. It was Starling's first tearoom, later followed by another that she ran in her father's (Sanford Sterling) house in a location behind the old Monhegan store. This house burned in the store fire of 1963. The boat probably belonged to Alphonso Speed whose wife's name was Jennie Belyea. In the background are the Stanley and the Peterson fish houses. (Cynthia Hagar Krusell.)

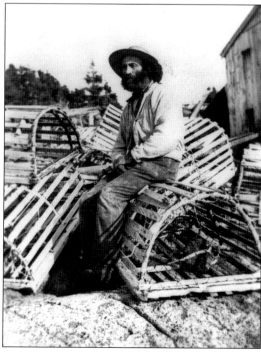

Harrison Humphrey was the well-known village blacksmith. He came to Monhegan from Bristol in 1861 when he was 20 years old. His father, Joseph, had been appointed the light keeper for the Monhegan light. When his father died, Harrison became keeper of the light and continued his blacksmith work until he died in 1918. The Humphreys at first rented the house at the corner of the road to Ice Pond, a house later owned by Jessie Dunbar.

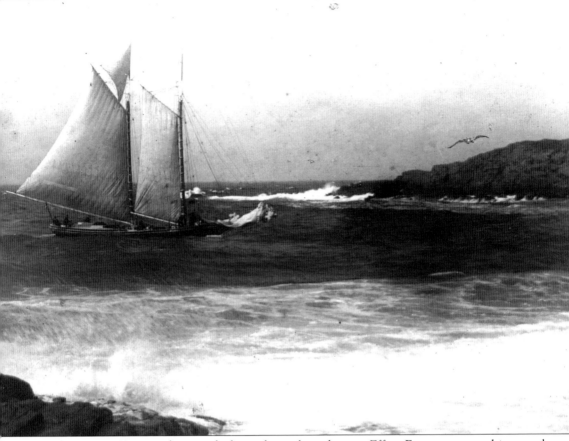

This S. P. R. Triscott photograph shows the packet schooner *Effort*. For many years this rugged vessel made the mail run faithfully from Boothbay Harbor. U.S. postal service to the island was started in 1883 from Port Clyde. The mainland point of departure was changed to Boothbay in 1884 and later to Thomaston in 1908. The *Effort* became more connected with the Monhegan mail route than any other boat in the days when the island was only a small fishing village. The *Effort* weathered the great *Portland* storm of 1898 when she was caught between Boothbay Harbor and Monhegan. She ran the mail route until 1907, when her longtime faithful captain William Humphrey had to resign because of ill health. Captain Humphrey was the first mail carrier hired by the U.S. Postal Service to carry the mail to Monhegan. He remained in this position for 25 years, making his scheduled trips in the sloop *Goldsmith Maid* and later in the schooner *Effort*.

Three

A WORKING ISLAND

On this remote island, the postal service was an important part of daily life. This is a 1920s picture of longtime postmistress Elva Brackett standing outside her first Monhegan post office, the Barnicle. Brackett was postmistress on the island from 1918 to 1960. Earlier postmasters and postmistresses were Lewis L. Lowell in 1882, Edmund P. Stevens in 1883, Mary Stevens in 1884, and Daniel Mansfield Davis for 27 years from 1891 to 1918. Davis ran the post office from a fish house on the wharf known in more recent years as the Rockcrest Gift Shop and the Lady Bug.

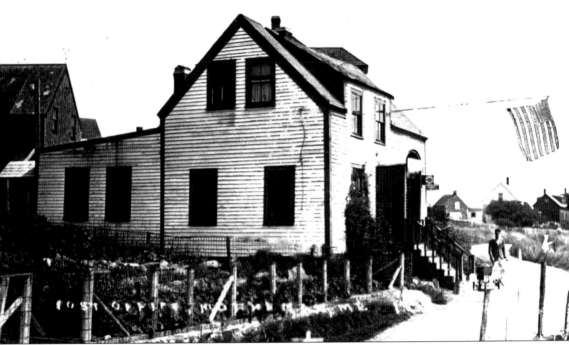

This is one of several buildings that were used over the years as a post office on Monhegan. Now painted pink and called the Carina, it was yellow when Elva Brackett had a post office and store here. This was the location of Brackett's second post office. The house was built by her father, Cass Brackett, around 1920 for her. She continued to use this building until 1929 when she moved the post office location to the Ponderosa. Elva sold the Carina to Sidney Baldwin who used it as her art studio. Later it was sold to Robert Semple.

Elva became synonymous with the mail on Monhegan, serving as postmistress for 42 years. Here she is outside the Ponderosa about 1935. Located at the intersection of the road coming up from the wharf and the main road, the Ponderosa was built by Maynard Orne in 1929. The post office was located on the north side of the house, and people waiting for their mail would sit across the road waiting for Elva to do the sorting and distribution.

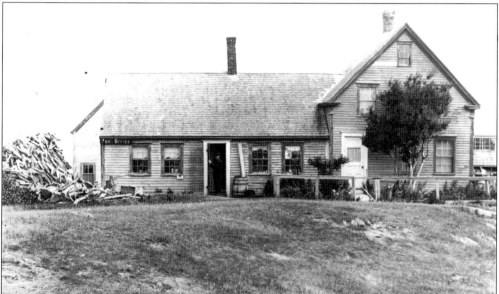

The John Sterling House, built about 1809, was the location of the post office during the time when Daniel Mansfield Davis was postmaster (around 1906). This picture shows the small original house. Later Davis raised the roof on the low ell part of the building as can be seen in the next picture. This house, located at the top of the hill coming up from the wharf, was the home of Rita White and Lila Davis Pepper for over 50 years beginning in 1952.

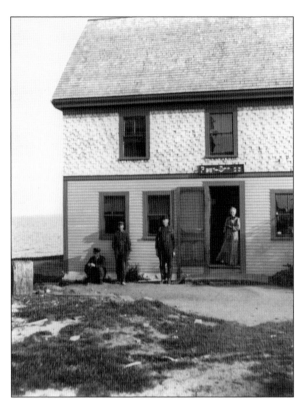

During the early 1900s, Daniel Davis and his wife, Alta, not only had the post office here but also ran a small store and sold canned goods from this house. An earlier store run by a Mr. and Mrs. Roberts around 1878 was located where the Periwinkle later stood.

This house was probably built by Moses Starling when he was married in 1847. Occupants over the years were Adolf Stevens, Courtland Brackett, Charlie Davis, and Ruth and Richard Nunan. It became the location of the Monhegan Post Office in 1968 when Vernon Burton had the porch enclosed to house the new office. The postmistress was Winnie Burton. Located at the top of Wharf Hill, it was a convenient location for the delivery of the mail from the boat.

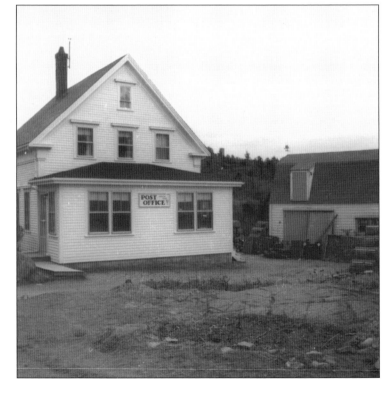

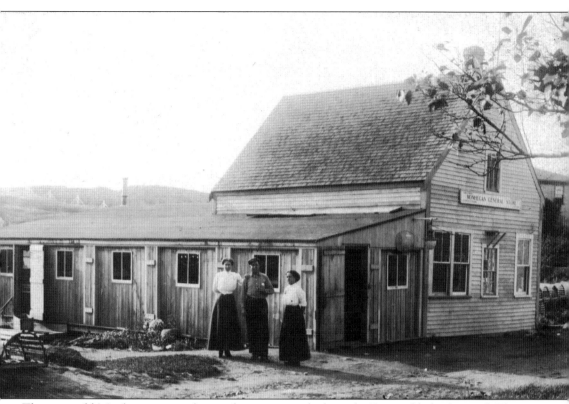

This is an old Monhegan general store that once stood where the Periwinkle lately stood. The Roberts family started a store here about 1878. In the long-side ell, George Cazallis operated an ice-cream parlor. A still earlier store operated in the early 1800s is thought to have been the Jacob Horn store located in the Stanley (then Horn) fish house. Horn was said to have illegally sold liquor and, as a result, lost all his property on Monhegan. The Roberts Store was at first owned by Walter Davis. It later was run by the Lane family and became known as the Lane Store. Still later it was owned by Ed Porter and run by Henry Shaw. A string of other people managed the store over the years. Dint Day built the Periwinkle in 1969 on the site of the old Roberts Store.

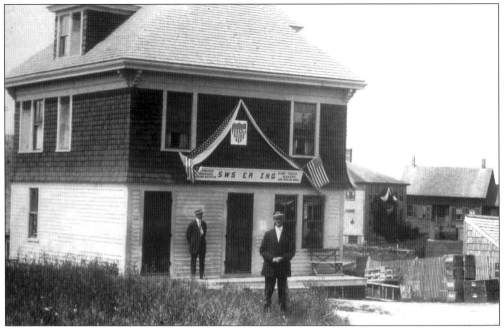

This S. W. Sterling store evolved over time into the Monhegan Store, a place of vital importance to the life of the island. Built by Sanford Sterling about 1913, it was a two-story building with living quarters on the top floor. It was built on some of the original Horn family property and was a central gathering point for the islanders. These two men perhaps are waiting for the doors to open or simply posing for the photographer. (Cynthia Hagar Krusell.)

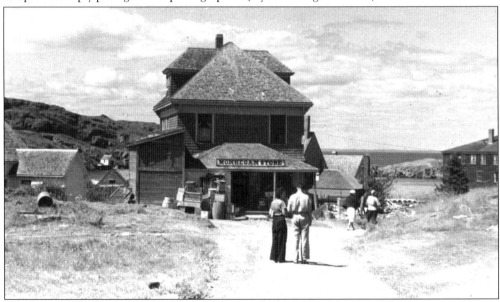

Here the old Sterling store has become the Monhegan Store. The addition of the front porch provided the customers a place to gather protected from the elements. Later under the ownership of the Odom brothers (around 1940), the porch was closed in to increase the floor space. Surrounded by several other storage buildings, the store commanded a wide view of the harbor and Manana beyond.

Here the old Monhegan Store can be seen with the porch closed in. This old store burned in a fire of November 1963. The Odom brothers, Harry and Doug, had a new store built on the same site by Banes Stanley. It provided groceries and supplies for the islanders for many years. The Odoms ran the store until 1979 when Bud and Sally Murdock undertook the management. In later years, it was run by Jack and Mary Bell. The pickup trucks seen in this picture are the only means of transportation on the island, with the exception of a few golf carts. They truck everything from the visitors' luggage, furniture, firewood, gas tanks, and sometimes the island children for a fun ride.

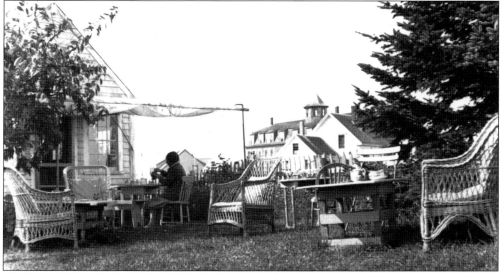

Ida Proper's tearoom, located outdoors on her back lawn, was a popular gathering spot in the 1920s and 1930s. In later years, Newt Searles lived here. Ida Sedgwick Proper was not only known for her tea but became one of Monhegan's first historians. In her 1930 publication *Monhegan, the Cradle of New England*, she writes of the Native American history and the early exploration and settlement of the island. She was also a well-known artist, doing much of her painting during her visits to Paris.

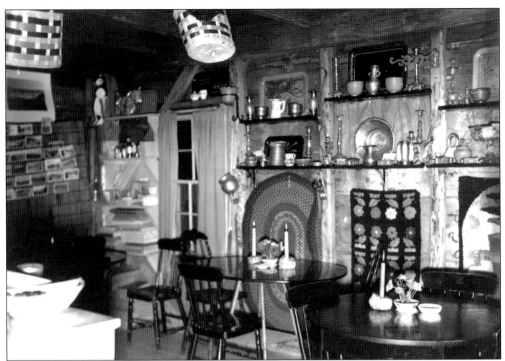

Nona Timson had her tearoom down near the wharf. Here is a glimpse of the inside with its inviting little tables set with candles and flowers. It would have been such a cozy place for tea on a rainy afternoon or on a cold day in June. Timson was especially famous for her brownies and ice cream. The tradition of tea on this far-off island is continued today with an annual Tea-by-the-Sea event to raise money for the Monhegan Library. At one time, people prided themselves in dressing up for this special occasion, but today it is a more informal event. (Margot Sullivan.)

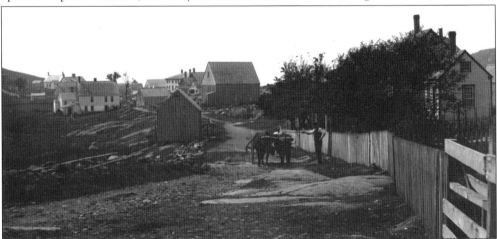

Oxen were for many years one of the chief means of hauling on Monhegan. Here is William Humphrey on the road with a team of oxen about 1895. Notice the fencing that is no longer there, but in that era it was necessary for keeping livestock in their pastures. The oxcart may be loaded with wood, coal, or freight that has arrived by schooner at the wharf. Oxen, as well as steers and cows, were used for hauling everything including heavy fishing seines and loads of wool freshly clipped from the island sheep.

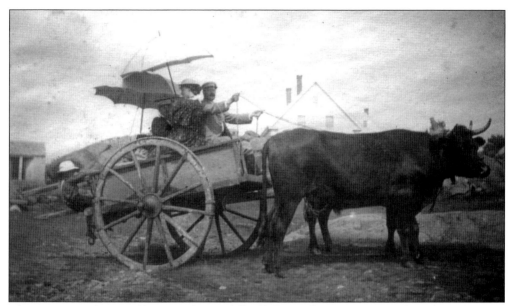

These oxen are the proud bearers of a cart full of ladies with their parasols. The man at the reins seems to be enjoying this jaunt also. Are they off to a tearoom or to the Influence? Or are they just hitching a ride to the wharf for a trip to the mainland? And why has the little boy jumped on behind? Apparently oxen were not always used for serious work. (Cynthia Hagar Krusell.)

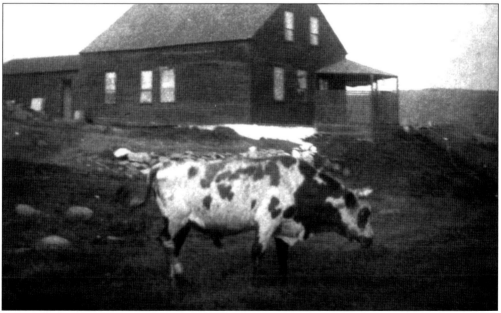

This bull grazing in a stony pasture on Monhegan would have been a common sight on the island in the late 19th and early 20th centuries. Cattle of all types were used as draft animals. Some types, such as Devon steers, were particularly well suited for island life and could survive on short rations. The story goes that in the 1920s, the Bracketts owned a cow that was shipped out on the mail boat for the summer to supply milk to the Monhegan House. She became singularly adept at negotiating the steep gangplank up from the boat to the wharf, much to the amusement of onlookers. (Cynthia Hagar Krusell.)

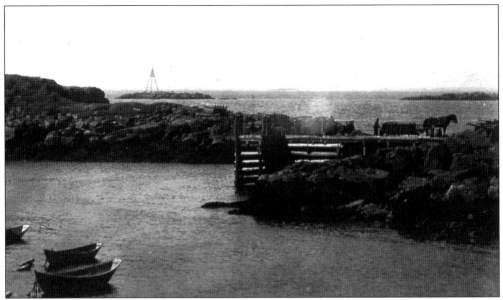

One of the earliest wharfs built on the island, this is a smaller dock than is seen today. A draft horse, probably hauling a load of wood, is getting ready for the steep trip up the hill to the main road. In the 1830s, agriculture and fishing were the main industries of the island. The land was cleared and cultivated. Good crops were raised, and many families kept swine and sheep as well as cows. (Cynthia Hagar Krusell.)

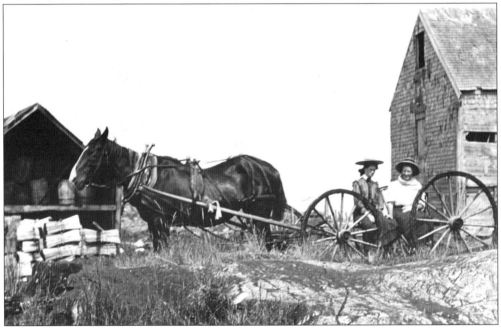

This sway-backed horse, known as Matinicus Charlie, belonged to Hiram Cazallis. Cazallis was a familiar figure around Monhegan in the early 1900s, but no more so than his horse that appears in many of the old pictures of the island. These women in their fancy hats and long skirts seem to be enjoying their ride along the island's only road. A visitor in 1880 wrote that the island had "no roads, nor use for any except to haul a little wood from the other end of the island in winter."

By the late 19th century, most of the island was clear and used for sheep pasture. This rustic fence with turnstile was built to control wandering cows. On this small island at sea, livestock were generally fenced out rather than in. Some sheep were fenced in with a special sheep-tight fencing noticeable in many of the late-19th-century pictures of the barren terrain of the island.

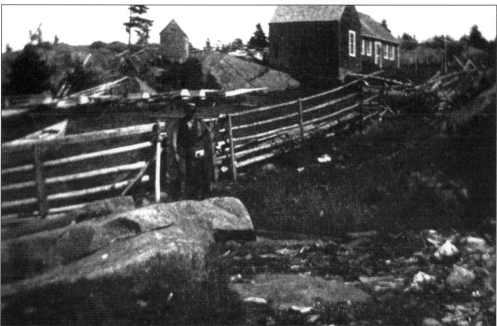

This man is standing next to his straight, well-built fence. As Henley Day once said, "A man gets by with less here. He don't need an auto or a fancy wardrobe. And he's free of responsibilities for all those possessions. And free of the pressures of shoreside living." One wonders how much nourishment the cows were able to glean from this rocky pasture. (Cynthia Hagar Krusell.)

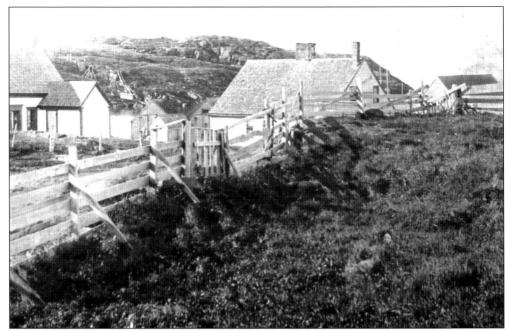

As Joseph W. Smith wrote in *Gleanings from the Sea* in 1887, "The zig-zag fences and capsized stone walls were once built to keep the wandering cows from the little gardens, where the flowers are of unusual beauty and brilliancy, acquired from the salty atmosphere." (Cynthia Hagar Krusell.)

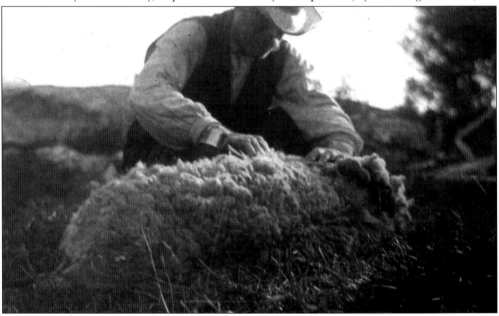

Here is spring sheep shearing on Monhegan. By the early 1890s, there were said to be about 250 sheep on the island. Except for the annual shearing and the marking of the lambs, the sheep roamed about with very little care. In winter, they subsisted on kelp and rockweed. In the early 1900s, concern for the safety of these sheep arose at the Maine Society for the Protection of Animals. Pressure was put on the islanders to provide sheds and hay for these wandering animals. When this did not work, the sheep were finally removed in 1911. (Cynthia Hagar Krusell.)

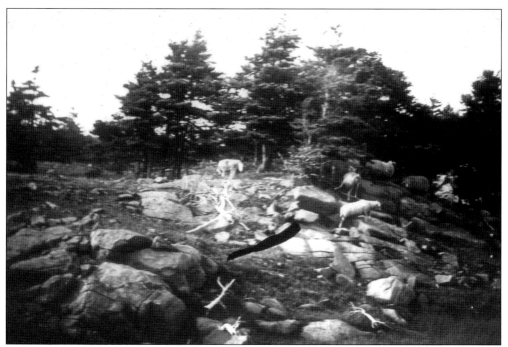

Note that the sheep in this image are free roaming, climbing over the rocks with not a fence in view. Monhegan's rocky landscape was described by Smith in his *Gleanings from the Sea* in 1887, "One stony, grassy lane twists about among the buildings, sometimes sending off a footpath toward the straggling cots out among the hillocks." (Cynthia Hagar Krusell.)

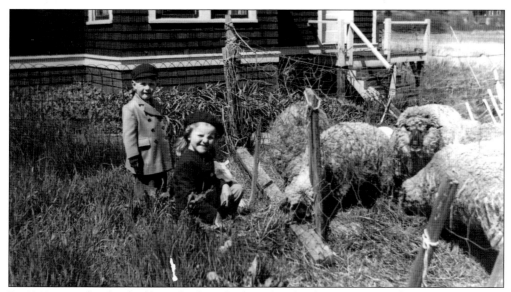

By 1948, some families had brought sheep back to the island. Here Barry and Margot Timson are tending some sheep, or are the sheep looking after them? The old crooked wooden fencing has been replaced by wire fencing, and the sheep look well fed and well cared for. It would not seem that they subsisted on kelp and rockweed, or that they wandered about over the island as they had done half a century before. (Margot Sullivan.)

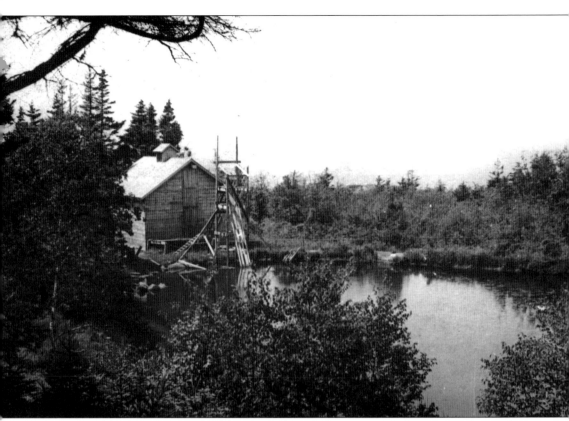

As Alta Ashley writes in her booklet about the Monhegan Ice Pond, no one seems to know just when it came into existence. It is an ever-popular spot for walking, birding, and studying wildflowers in summer and skating in winter. Before 1900 and until the recent past, the Ice Pond was used for the important industry of supplying ice to the island stores, hotels, residents, and fishing industry, hence the pond's name. Here the large icehouse is seen that was built in the late 1940s to replace an older, pre-1900 barn. It was used for storing the ice in sawdust. The tall post structure was called the elevator shaft, along with the ice chute this enabled the ice cutters to transfer the ice from the pond to the barn.

In the foreground is the cutting-off saw used in the ice harvest. After the groover marks off the ice in rectangular pieces, the cutting-off saw cuts the blocks of ice away, and the workers guide the pieces of ice toward the elevator and chute. Here Dana Little (left) and Doug Odom are seen using picks to guide the ice cakes, while Tom Watson in the background is using the groover.

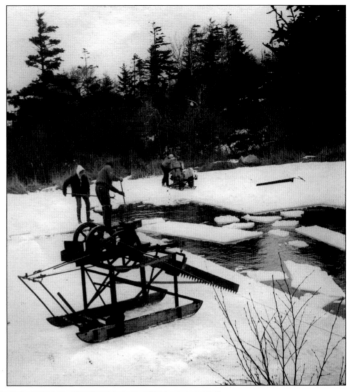

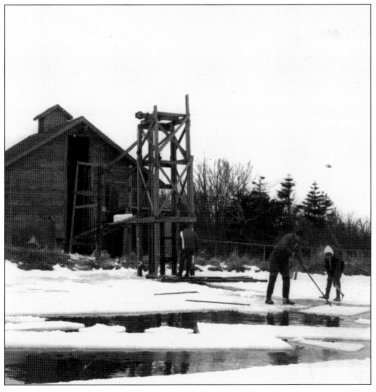

As the cakes of ice are cut away, they are poled toward the elevator shaft. Here are Doug Odom and Dana Little working at the ice cutting process in late February 1967. After the advent of gas refrigeration and with the fishing industry dwindling, the demand for ice fell off, and in 1966, the pond and icehouse were sold. In 1967, a private company, known as the Crystal Ice Company, was formed to supply ice to the summer residents after ice was no longer needed for commercial purposes.

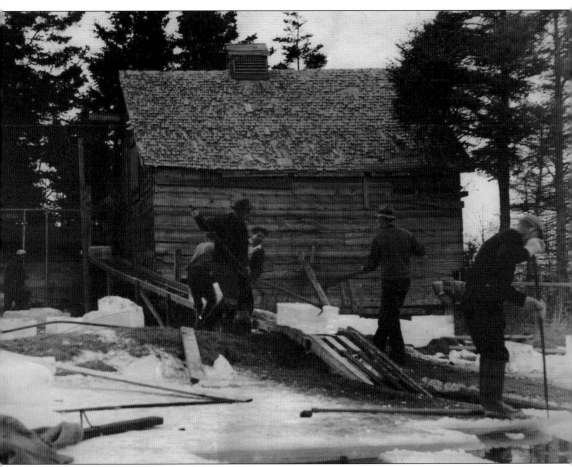

One of the final acts of ice production was moving the ice blocks along the ramp to the ice barn. There the ice was, as Alta Ashley wrote, "piled in neat rows, row on row until the eaves were reached." In earlier years when there was a large demand for ice and as the summer population increased, sometimes additional ice was cut from the meadow and even imported from the mainland on the steamer *May Archer* and hauled up from the wharf by Hiram Cazallis and his horse and dray.

Four

HERE THEY COME

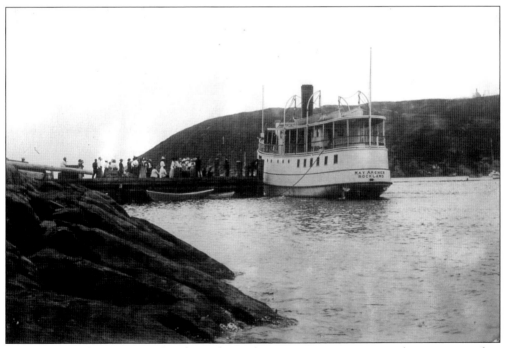

Late in the 19th century and early in the 20th century, summer visitors (rusticators as they were called) began to make their way to Monhegan. The steamer *May Archer* built about 1907 made regular three-hour trips from Thomaston to Monhegan, bringing passengers and building supplies. (Cynthia Hagar Krusell.)

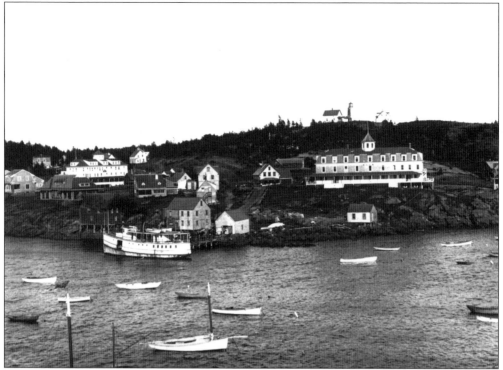

The *May Archer* is at the wharf in 1910 delivering people and supplies as well as boarding returning passengers. Most of the lumber for the Island Inn, the long building with the cupola, came over on this vessel. The first and second additions to the Island Inn were constructed during the service time of the *May Archer* (1907–1916).

With a grin on his face, Frank Pierce is holding on to a pylon, most certainly checking out the docked *May Archer* (1907). This crowd is almost as large as current lines of visitors today, but dress is formal and fashionable, and everyone is wearing a hat.

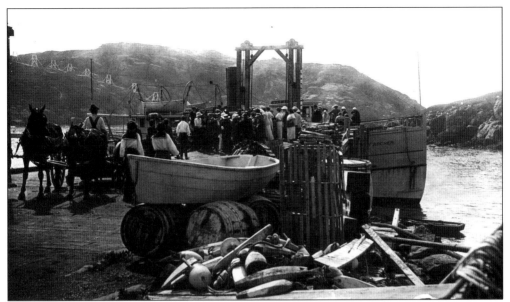

The wharf was the only place for the arrival and departure of visitors. It had to provide space for pick up of supplies by horse and carriage and storage of skiffs, barrels, traps, and whatever else was coming and going. Before and after 1900, Capt. William S. Humphrey brought the mail from Port Clyde to Monhegan in his sloops *Goldsmith Maid* and *Effort*.

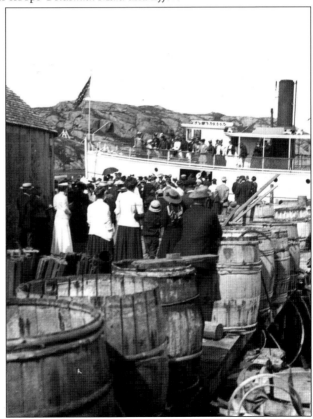

The crowds on the wharf await the arrival of the *May Archer*. The barrels might outnumber the onlookers.

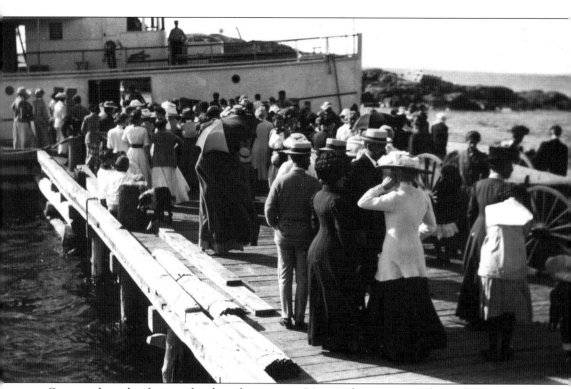

Compared to the ferries of today, the steamer *May Archer* was quite large, having several staterooms, wide decks, a heated salon, and even a place to play cards. Capt. Isaac Archibald would steer the steamer down the St. George River and across the bay to Monhegan.

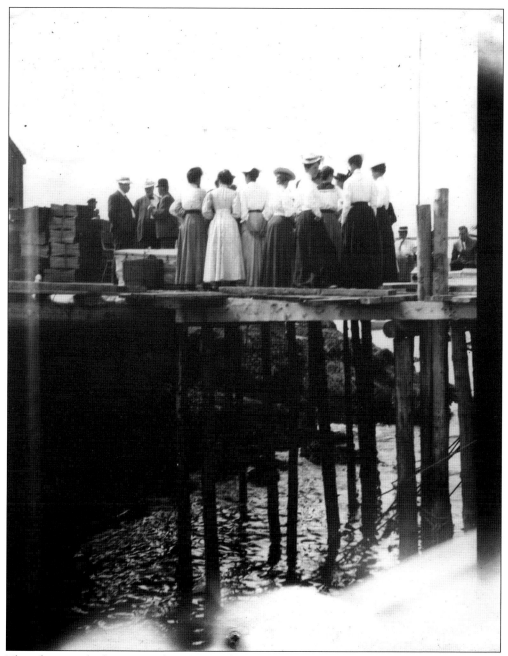

This photograph, from around 1910, provides a great view of the wooden wharf with the open pylons below revealing the wharf's structure. Before Monhegan had a wharf, vessels arriving and departing would have to use the beach areas to unload. One wonders why the group of formally dressed ladies has gathered together on the dock.

A VISIT TO MONHEGAN ISLAND,

Maine, September, 1918,

BY

JOHN W. DEWIS, M.D.

THE FALL MIGRATION OF 1918

AT

Monhegan Island, Maine,

FROM LETTERS OF

BERTRAND H. WENTWORTH

OF GARDINER, MAINE,

Compiled by Charles F. Jenney.

(Reprinted from Records of Walks and Talks with Nature, Vol. XI, p.p. 21-41.)

Rusticators, artists, and even bird-watchers discovered Monhegan after the beginning of the 20th century. In 1918, Dr. John W. Dewis records his observations on a bird-watching trip to Monhegan. This wonderful document together with others was compiled by Judge Charles Jenney of Hyde Park, Massachusetts, a noted ornithologist as well as a builder of houses on Monhegan and an active summer member of the Monhegan community. (Margot Sullivan.)

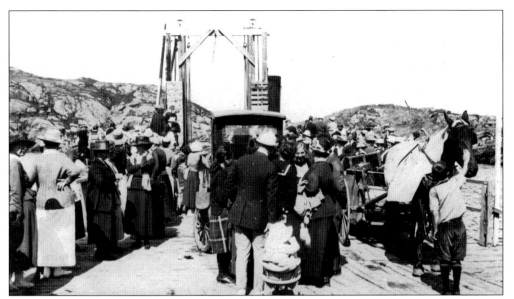

In 1920, this crowd at the wharf must share space with not only a horse and buggy but also a truck. Any time a vehicle comes over to Monhegan on a boat or barge, the occasion draws crowds of spectators. The maneuvering is interesting and, of course, one has to know who is getting the latest addition to the vehicles on the island.

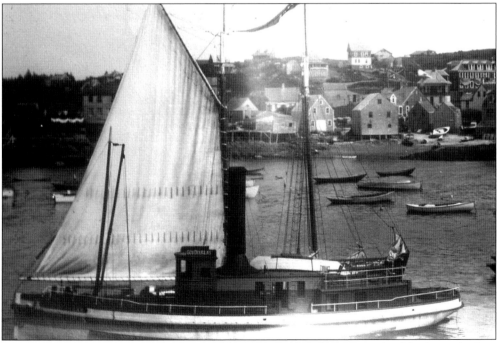

The handsome *Governor Douglas*, captained by Isaac Archibald, is moored in Monhegan harbor. This vessel brought passengers, supplies, and mail from 1911 to 1932. Note the many buildings hugging the shore and the activity at Fish Beach. (Cynthia Hagar Krusell.)

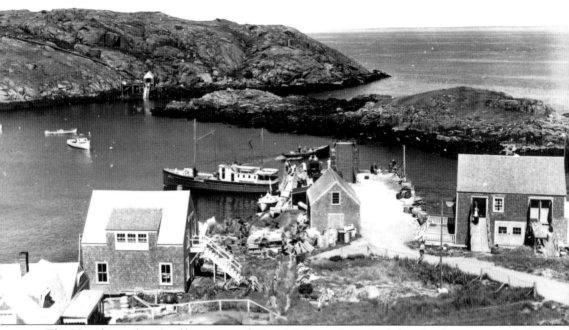

The *Nereid* is at the wharf here, around 1940. This vessel serviced the island intermittently for many years from Boothbay Harbor. The building on the right has a tearoom on the second floor. The small building on the wharf is used for storage. Built by the U.S. Coast Guard, the ramp access to Manana, the island across the way, is clearly visible. Smutty Nose is the name of the rocky ledge separating Monhegan and Manana. Over the years, Smutty Nose has been the site of numerous boat wrecks from torn moorings or storms. (Margot Sullivan.)

Here Capt. Earl Starrett of the *Nereid* is seen. (Margot Sullivan.)

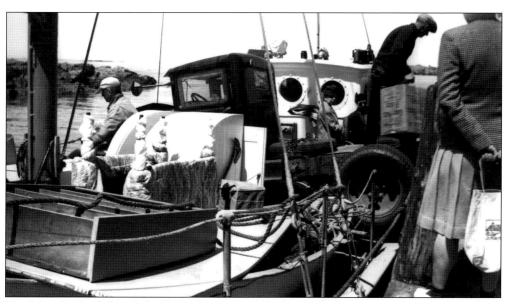

The *Nereid* is loaded with freight and a truck. Onlookers will enjoy seeing this vehicle back off the boat. (Margot Sullivan.)

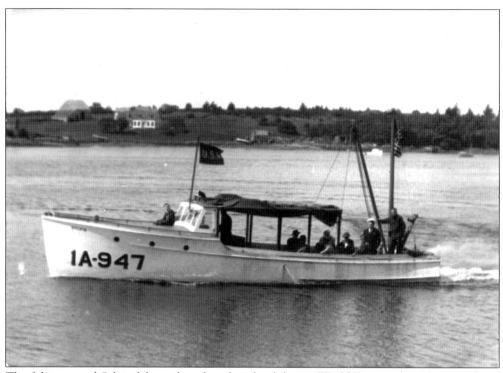

The fishing vessel *Sylvia* delivered mail to the island during World War II when the *Nereid* was commandeered by the U.S. government for other service. The *Sylvia* was a lobster boat owned by Earl Field. According to Ruth Faller in her book *Monhegan: Her Houses and Her People, 1780–1970*, Capt. Earl Field would take people on moonlight cruises around the island on the *Sylvia*.

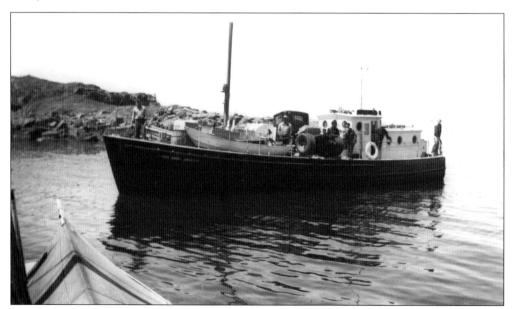

After the *Sylvia*, Captain Field brought mail, freight, and passengers over on the *Captain Samuel Jamieson* (1947–1954). Here the boat, heavily freighted, is seen entering the harbor in 1947.

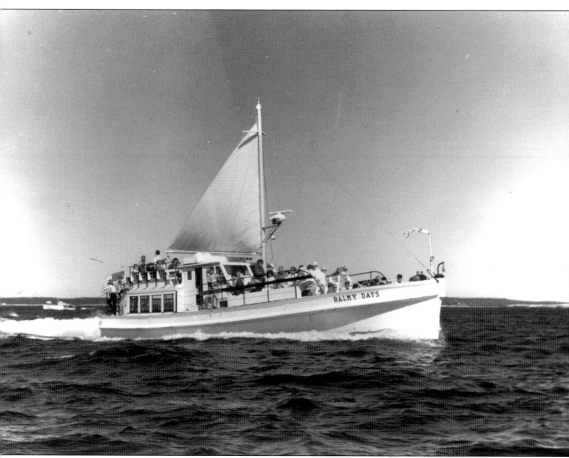

"Are you going around the island, Captain Wade?" is sung to the tune of "She'll be coming round the mountain." Visitors used to sing this to Capt. Charlie Wade, a popular boat captain of the *Balmy Days*, originating from Boothbay Harbor. The *Balmy Days* was in service from 1932 to 1988, when a larger *Balmy Days II* was built to accommodate more passengers. The *Balmy Days II* makes a very popular afternoon run around the island for tourists to see the headlands from the water.

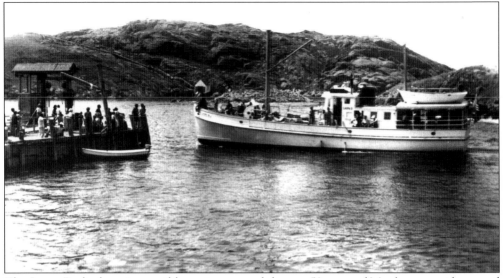

The *Laura B*, the longtime mail boat, is near and dear to 50 years of Monhegan residents and visitors. The boat was built by the U.S. Army in 1943 and is considered the most seaworthy vessel to make year-round trips to Monhegan. The run between the mainland and the island is the longest open-ocean crossing for any boat service bringing mail to a Maine island. From Port Clyde, this boat has brought mail, freight, trucks, cars, dogs, cats, parrots, hamsters, residents, visitors, furniture, and anything else people wanted to bring out to Monhegan.

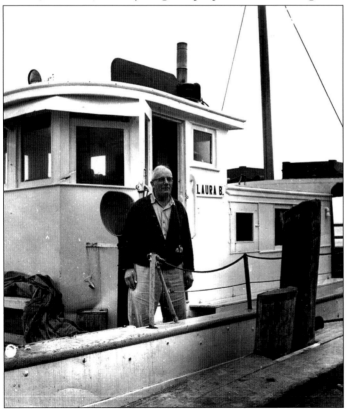

Capt. Earl Field of the *Laura B* was a familiar figure at the Monhegan wharf and the Port Clyde wharf. His son Earl took over captaining the boat until 1977 when Jimmy Barstow bought the boat. The *Laura B* still makes an early-morning summer freight run. In 1995, the Monhegan Boat Line built a new passenger ferry, the *Elizabeth Ann*, to accommodate the ever-increasing load of passengers.

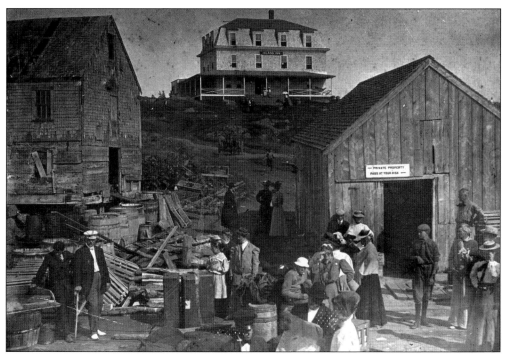

Early visitors would come and stay at the Island Inn, the building seen at the top of the hill coming up from the wharf. In 1906, Frank Pierce bought the Pink House (yes, it was painted pink) from Josiah Starling Jr. and built the inn. This is a view of the original inn, and Pierce made two enlargements resulting in the building of today.

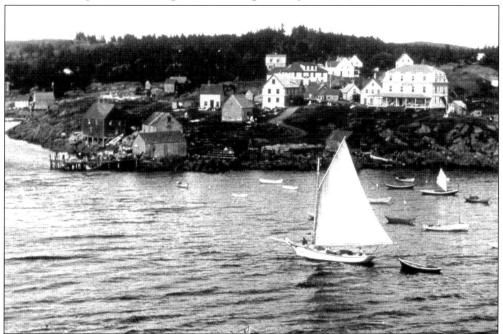

Here is a great view of the harbor with the original Island Inn on the right. A wonderful porch to sit and watch all the harbor activity existed then, as it does today. (Cynthia Hagar Krusell.)

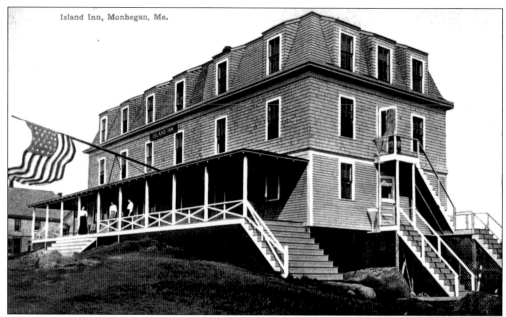

Island Inn, Monhegan, Me.

This early postcard is an excellent photograph of the Island Inn, showing it with Frank Pierce's additions. Guests loved viewing the harbor activity and sunsets from the rooms and porch. (Margot Sullivan.)

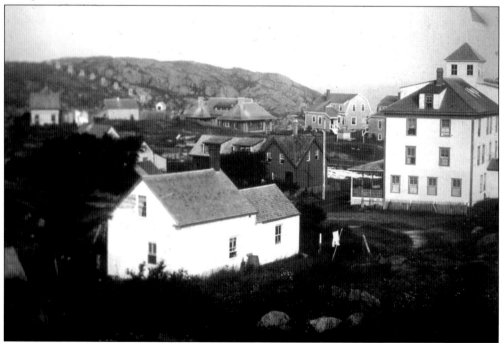

The old Monhegan House was located just below the current schoolhouse (the white building in the foreground) and served as a popular inn for visitors for many years. Edward Brackett bought a house on the site, built up several stories, and added a great wraparound porch. The view must have been excellent. In January 1924, the building was destroyed by fire and never rebuilt. (Cynthia Hagar Krusell.)

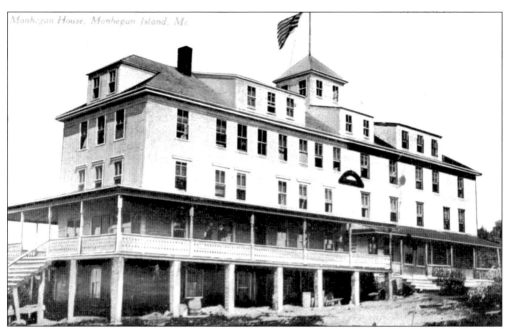

The old Monhegan House was a great place to stay. (Margot Sullivan.)

This large family dwelling across from the church was purchased in 1888 by Sarah Albee from Trefethren heirs, hence the name old Albee House. Albee was one of the first islanders to offer rooms for visitors and artists. She enlarged the building in several ways over the years. It evolved into what is today the new Monhegan House. In 1927, Elva Brackett Nicholson became the proprietor/owner until her death in 1976. (Cynthia Hagar Krusell.)

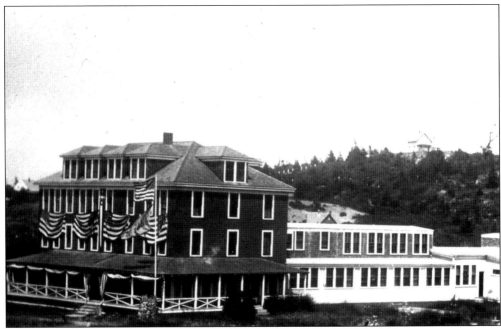

The Albee House (later the new Monhegan House), obviously enlarged, is decked out for the tercentenary of 1914. (Cynthia Hagar Krusell.)

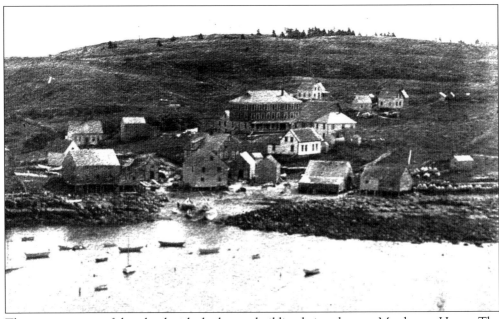

This is a nice view of the island with the largest building being the new Monhegan House. The island looks incredibly bare of trees as much of the land was used for pasturage and farming. Now forest and shrub growth covers much of the island. (Cynthia Hagar Krusell.)

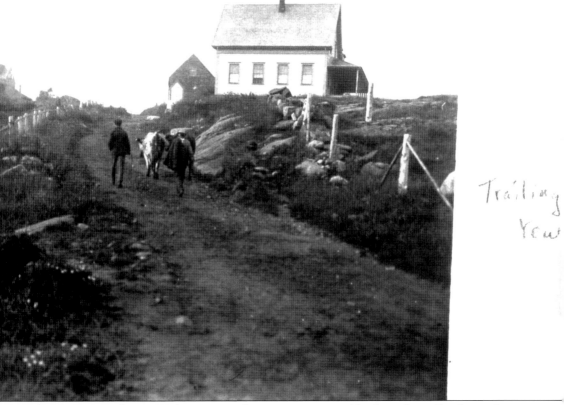

Trailing
Yew

In the 1920s, several rooming houses served visitors, artists, and bird-watchers. On the road to Lobster Cove, the Trailing Yew was opened for business by Josephine Davis in 1926. Jo Day, as she was affectionately known by islanders until her death in 1996, was the friendly proprietor of this informal inn. Simple but huge platters of food were always served boardinghouse style. Guests loved the Trailing Yew and now, as then, continue to return for the camaraderie and casual summer vacationing. Tribler Cottage (pictured in the top image on page 35) was purchased by the Tribler sisters in 1908, enlarged with many rooms, and eventually used as an annex to the Island Inn. (Cynthia Hagar Krusell.)

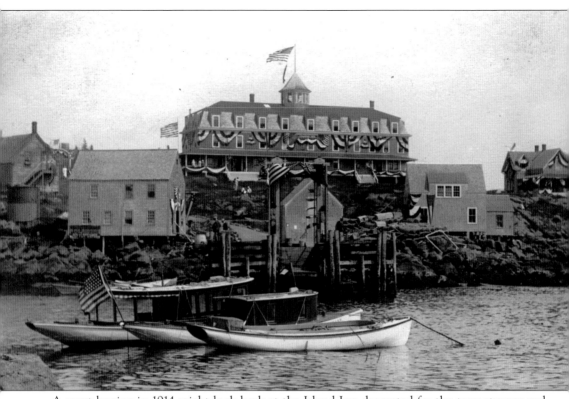

A guest leaving in 1914 might look back at the Island Inn decorated for the tercentenary and see all of the flags on boats, homes, and flagpoles. Monhegan Island has always known how to celebrate.

Five

THROUGH THE ARTIST'S EYE

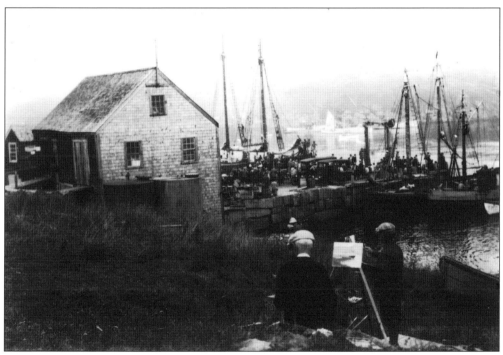

The Monhegan wharf, with a variety of fishing and sailing vessels in the harbor background, has been a subject for artists since before 1900. From winter seas and chilled fishermen to summer ferries and visitors, the dock with all of its variety of activities is a focal point for artists. Here two unknown painters have a striking view of the fishing boats and the busy islanders orchestrating comings and goings.

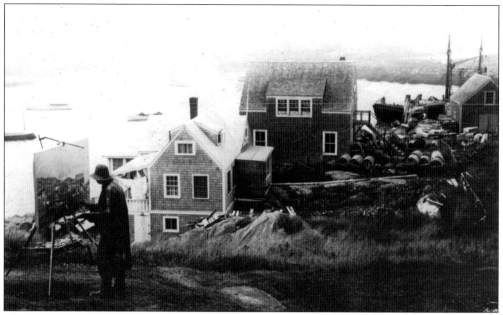

The American impressionist artist Edward Redfield (1869–1965) first visited Monhegan in 1903. Redfield is standing below the Island Inn in 1928, painting the harbor scene but mindfully well dressed for possible weather changes. Redfield was one of a group of artists who preferred working en plain air (painting in the open air). In later years, he was a harsh critic of his own artwork, burning some of his paintings in 1947. Redfield was somewhat ignored in art circles, but no longer, as collectors realize his talent and contribution to American art.

S. P. R. Triscot (1846–1925), a watercolorist, photographer, and year-round island resident for over 20 years, is seen on the left, with Charles Jenney on the right. Perhaps the woman has a broken ankle? Jenney was an important Monhegan summer resident, building two homes and helping to incorporate the Monhegan Land Company early in the 20th century. The two men are friends, and Jenney bought many of Triscott's watercolors for his home in Hyde Park, Massachusetts.

Some residents and visitors considered Triscott withdrawn and reclusive, especially in his later years, but clearly he immersed himself in the Monhegan community. Here he is seen with the fisherman Claudin Wincapaw (left) displaying a very large fish.

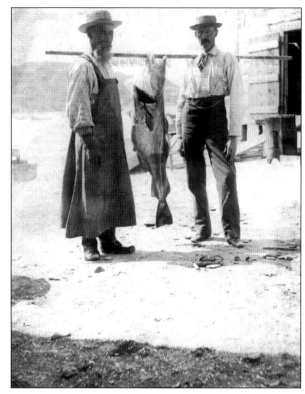

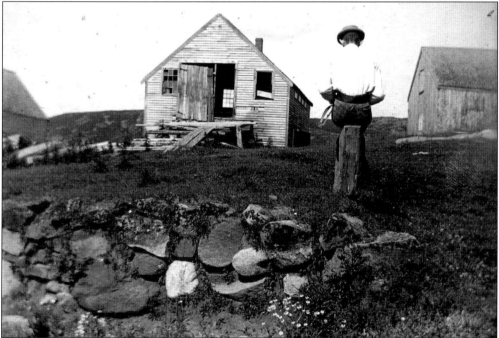

What a wonderful watercolor must have resulted from this view. Triscott is sitting on a stump sketching the fish house and scenery in front of him. His watercolors were romantic, peaceful, and detailed.

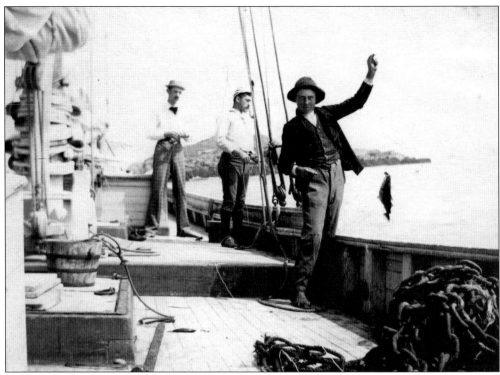

On the deck of a large sailing or fishing vessel S. P. R. Triscott and another artist, Frank Myrick (1856–1917), are possibly fishing or at least coming along for the ride, observing the unknown man on the right and his catch. Several other artists including Eric Hudson, George Everett, and George Edwards, were Triscott's friends especially in the early years.

The artists Myrick and Triscott are hanging out with George Humphrey and his dog.

Triscott came to the United States from Britain in 1871 and worked as an engineer in Boston while spending his free time painting. In 1892, he first visited Monhegan Island with his friend, the artist Sears Gallagher. During the next 10 years, Triscott literally fell in love with Monhegan, visiting during the summer and winter. This is the house he bought in 1902, where he resided with his numerous cats until his death in 1925. He did not leave the island at all for many years. At the time, Triscott's watercolors were numerous but not in great demand by collectors. Ironically he was found dead in his home the same day as the artist John Singer Sargent died in England. Triscott is one of the few artists buried in the local cemetery below the lighthouse. (Cynthia Hagar Krusell.)

Monhegan Island's magnificent cliffs are the subject here for Rockwell Kent (1882–1971), perhaps the most illustrious artist of the historic and well-known Monhegan art colony. In 1905, the artist Robert Henri (1865–1929) suggested that Kent come to Monhegan for one of his art classes. Kent was overwhelmed by Monhegan's beauty and painted incessantly. The Monhegan community of fishermen and summer folk also became part of his life. He worked on the island at various jobs and eventually, in 1906, built a small house for himself on Horn's Hill. He was a major carpenter for the twin Jenney houses still seen as one enters the harbor. Kent's landscape and seascape paintings were vigorous and overpowering, and he is now considered a major American artist of the 20th century. Kent left the island in 1910 but returned in 1947 only to find he was not welcomed by the community, as he was perceived to be a socialist.

A young Kent is seen standing in the doorway of the house (Kelsey Cottage) that he built in 1906. Kent also built an art studio nearby for his mother, Sarah Kent, which later was used by her niece Alice Kent Stoddard, one of Monhegan's celebrated portrait painters.

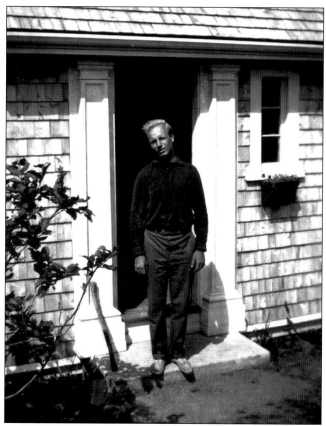

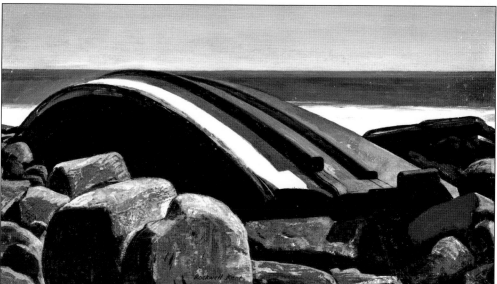

The wreck of the *D. T. Sheridan* at Lobster Cove is the subject of this well-known Rockwell Kent oil painting. On a foggy and windy November evening in 1948, the *D. T. Sheridan*, towing two barges, ran aground on the rocky ledges. At the southern end of the island, pieces of the rusty wreck are still scattered about the landscape today.

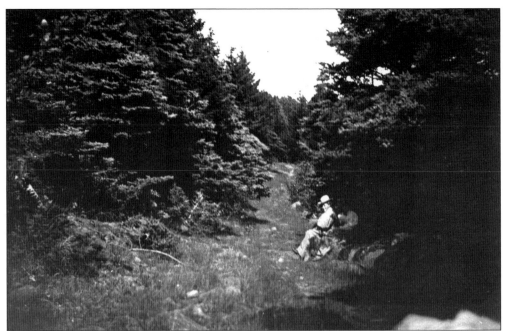

On the road leading to Cathedral Woods is seated Maude Briggs Knowlton (1870–1956), probably one of the first women artists to paint on Monhegan. Knowlton studied watercolor with S. P. R. Triscott. Arriving in the late 1880s, she eventually bought land and built a cottage in 1921 near Triscott's house.

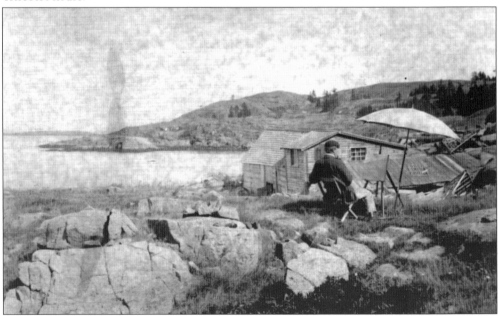

On his way to Mount Dessert in 1897, Eric Hudson (1862–1932) sailed into the harbor and so loved Monhegan that he built his imposing house Harbor Spruces on the shoreline the next year. Hudson became an accomplished artist noted for his portrayal of the form and structure of boats on the sea and his bold and strong rocks and surf. Here he is painting Harrison Humphrey's shack. Note his formal attire.

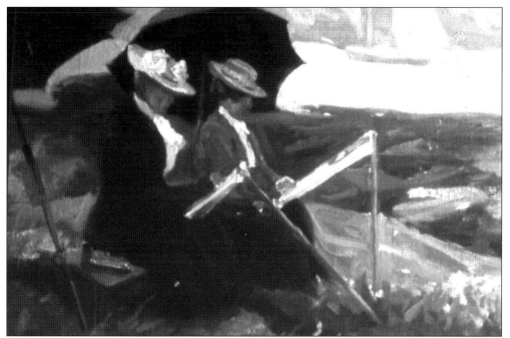

Maude Knowlton and Alice Swett Sketching is an oil-on-canvas painting by Eric Hudson, done around 1905. Both of these women were noted artists on the island. They certainly are dressed to the nines with fancy hats and imposing umbrellas, so unlike artists of today. (Cynthia Hagar Krusell.)

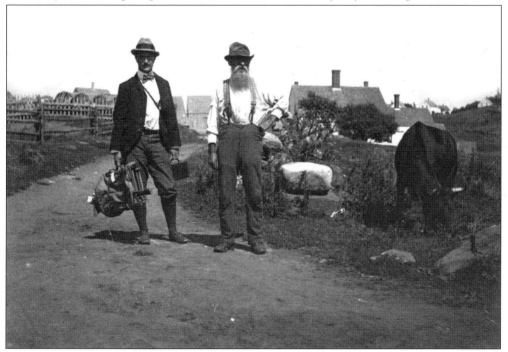

Sears Gallagher (1869–1955) visited Monhegan upon the invitation of S. P. R. Triscott and was known primarily for his etchings. Gallagher (on the left) probably has his art supplies, but Harrison Humphrey, the local blacksmith, appears to be on a leisurely stroll with the artist.

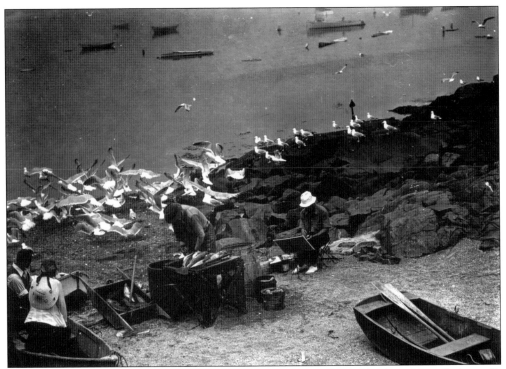

As he paints the fisherman, Sears Gallagher does not seem to be bothered by all the gulls awaiting fish parts to be thrown out to sea by Frank Pierce.

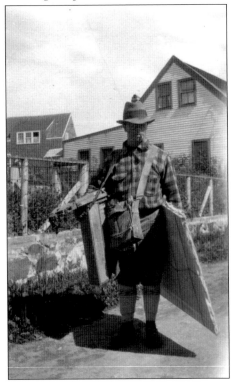

Abraham Jacob Bogdanove (1886–1946) painted on Monhegan in the 1920s and 1930s. A popular resident affectionately known as "Boggy," he was born in Russia but came to the United States and studied in New York with the Art Students League. For 28 summers beginning in 1918, he painted the landscape of Monhegan. Here he clearly is laden down with every possible art supply that he might need on a painting expedition.

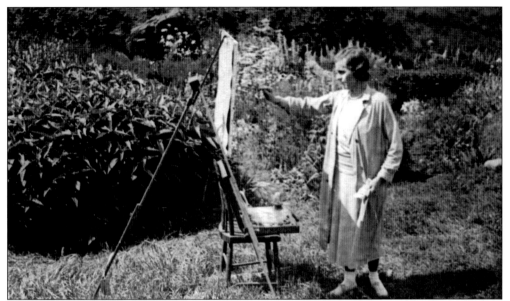

Constance "Connie" Cochrane (1888–1962) is painting in a garden, probably on her property where she had an art studio. Cochrane was a member of a group of Philadelphia artists, including Mary Townsend Mason (1886–1964) and Isabel Branson Cartwright (1885–1966), who painted on Monhegan. They were known as members of the Philadelphia Ten. Cochrane is remembered for her colorful paintings of flowers. Cochrane family members have maintained her cottage today just as it appeared and was used in the 1930s.

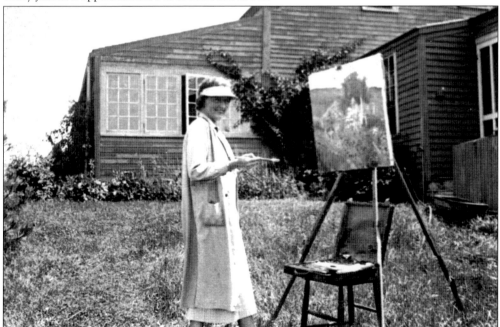

A lovely painting belonging to Marie Stevens, wife of the lighthouse keeper Daniel Stevens, by Isabel Branson Cartwright hangs in the Monhegan Museum on Lighthouse Hill. Along with Cochrane and others, Cartwright studied art in Philadelphia. Fashionably dressed, here she is painting a colorful landscape.

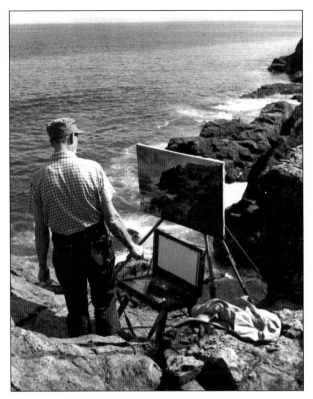

Originally from Estonia, Andrew (Andy) Winter (1893–1958) was a year-round Monhegan resident for almost 20 years. He arrived with another prolific Monhegan painter, Jay Connaway (1893–1970). Andy and his wife, Mary, were much-beloved community members. He not only painted but also was an accomplished woodworker, and he also tried lobstering and rug hooking. On a fine summer day, Andy is on the cliff side of the island painting.

LIGHT HOUSE HILL

Many of the Monhegan artists would create Christmas greeting cards to mail to family, neighbors, and friends. The illustrator Frederic Dorr Steele (1873–1944) built a cottage on Monhegan in 1907. He designed the large wrought-iron sign for the Monhegan Library. This greeting card reads "To Alice Kent Stoddard with island greetings from Frederic Dorr Steele Dec 1911."

Six

SHIPWRECKS, NAVIGATION, AND WEATHER

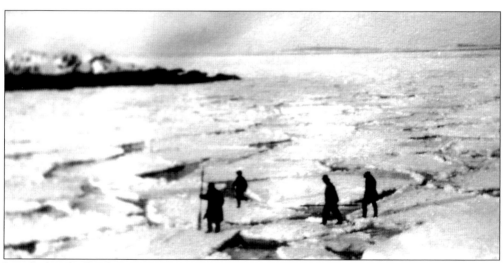

Long before the first shot fired at the Old North Bridge signaled coming American independence from British rule, the New World's colonists understood the value of trade and, perhaps more importantly, protecting that trade. While human enemies would come and go over the years, one constant and consistent foe, Mother Nature, relentlessly kept up her attack. In 1716, to defend mariners against her advances, the people of Boston constructed the first light station in the New World on Little Brewster Island, Boston Light. As trade increased at different ports, similar structures sprang up. In 1824, a lighthouse came to Monhegan Island, and in 1855, a fog signal sounded from Manana. Yet despite these efforts, Mother Nature still triumphed from time to time. (Cynthia Hagar Krusell.)

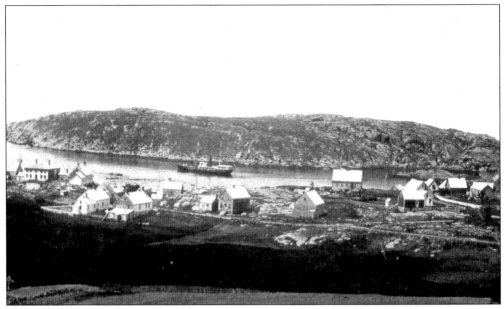

The harbor at Monhegan is not a traditional harbor, which is usually considered a safe haven shielding ships and sailors from storms. The passageway dividing Monhegan Island from Manana Island runs southwest to northeast. This channel is used as an anchorage. Nor'easters, or storms generating powerful winds from the northeast, are among the most feared meteorological events in New England. The channel's orientation makes the harbor at Monhegan one of the worst places to anchor during a winter storm. (Cynthia Hagar Krusell.)

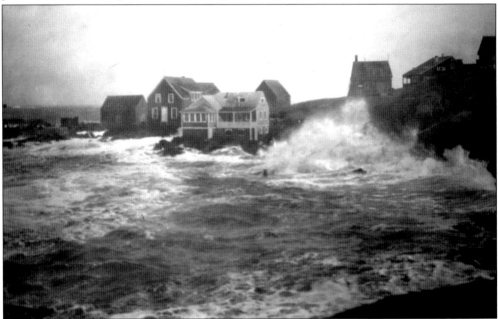

Winds from the southwest, too, could be problematic for fishermen, lobstermen, or others hoping to run and hide from a storm at Monhegan. Here southwest winds push the sea up onto the island. The island's rocky foundation will not budge. The man-made structures though, have not always fared so well. (Cynthia Hagar Krusell.)

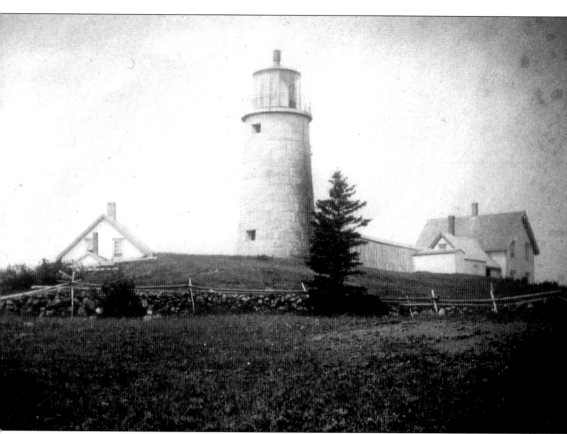

With commerce on the increase in the early 1820s, following the most trying time in history for America's merchant marine (thanks to the various Embargo Acts and the War of 1812), Congress under Pres. James Monroe authorized $3,000 for the construction of a lighthouse on the highest point of land on Monhegan Island (known then as Lookout Hill and now as Lighthouse Hill). The authorization came on May 7, 1822, and on December 11, the federal government purchased two acres for the light's erection from Josiah Starling. Built 30 feet tall of stone, the lighthouse first shone forth on July 2, 1824, helping to guide mariners around the rocky islands. Damaged irreparably by storms, the first tower gave way to a second granite structure in 1850. (Cynthia Hagar Krusell.)

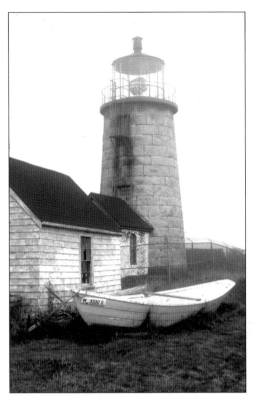

Raised to 48 feet in height after the reconstruction and showing its light at 178 feet above sea level, the tower is the second highest on the coast of Maine, behind only Seguin Light. The Monhegan lighthouse keepers have always had a tremendous view. From the tower they could see Seguin, Pemaquid, Franklin Island, Marshall Point, White Head, and Matinicus Rock lighthouses. (Cynthia Hagar Krusell.)

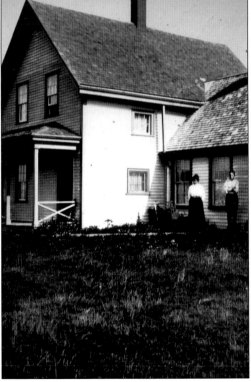

From 1824 to 1956, houses on the crest of the hill were home to those Monhegan Island Lighthouse keepers. Thomas Seavey, the first keeper, moved into the first house with his family upon the light's illumination. The last keeper, Henley Day, moved out of the last one in 1956. The Monhegan Associates purchased all of the structures on the property other than the tower in 1962 and six years later opened the Monhegan Museum. (Cynthia Hagar Krusell.)

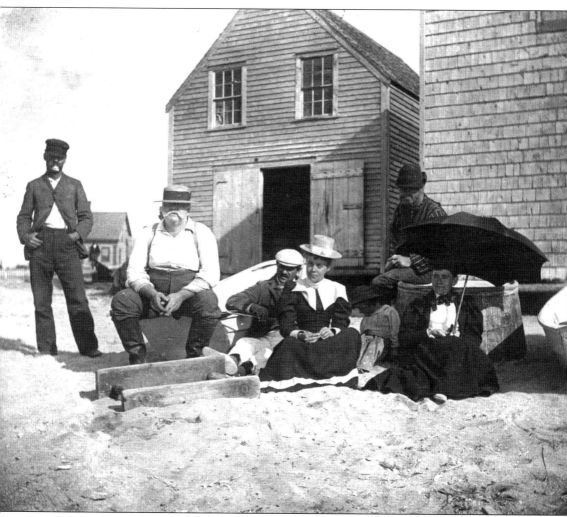

It took a special man to be a lighthouse keeper at a remote station, and Dan Stevens, seated in the white shirt at left, certainly fit that mold. A Boston transplant by way of the U.S. Navy, Stevens served first at the fog signal station on Manana for more than a decade before transferring to the lighthouse in 1902. "Why shouldn't we be satisfied?" he asked in response to an inquisitive *Boston Globe* reporter in 1904. "This is one of the loveliest spots on the great round earth. What do we want better than this? And it's all ours! We can look at it all when we want to, and breathe this good air, and be free and well and happy as anybody can be in this world." Stevens served as lighthouse keeper on Monhegan until 1919.

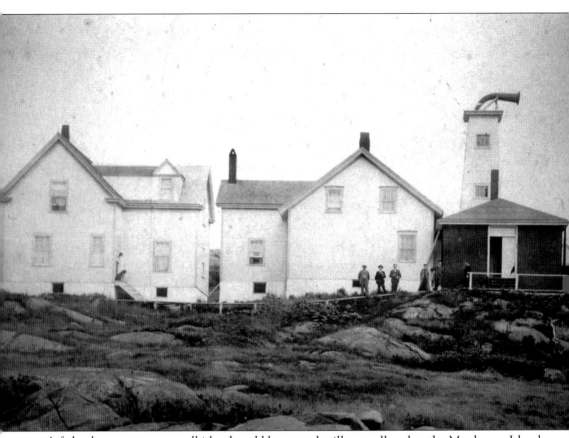

A federal presence on a small island could be a tough pill to swallow, but the Monhegan Island residents never showed any displeasure with the lighthouse or its employees. Far from being unwanted interlopers in the small community, the lighthouse keepers provided a thoroughly important service. The same could be said of the men who manned the Manana Island fog signal. The signal, called for by local boat captains, helped break up the danger of traveling along the Maine coast between Portland Head Lighthouse and White Head Light. Maine averages more than 800 hours of fog every year, some of which is completely impenetrable by beacons. Auditory signals from Manana—first a bell, then a trumpet, then a steam whistle, and then a trumpet again—helped steer ships away from the islands. Installed in 1855, the 2,500-pound bell, now on display outside the Monhegan Museum, had to be struck manually until an automated system was perfected. That made for some long nights for the man sworn to its use. (Cynthia Hagar Krusell.)

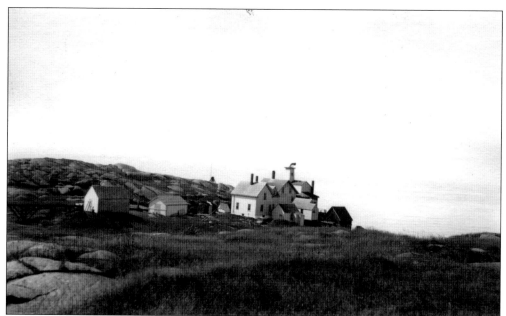

For the first two decades of its existence, the operation of the fog signal station fell to the lighthouse keepers of Monhegan. In 1876, the station became a separate entity, with its own dedicated staff. In 1896, the station's summer kitchen was enlarged to create room for an assistant keeper. Duty on Manana could be considered even more remote than that on Monhegan.

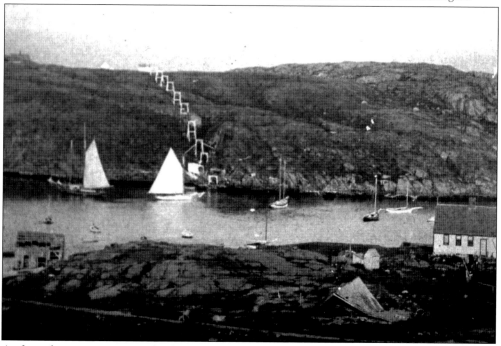

At first, the man operating the fog signal station would know it was time to go to work when a gong sounded in his bedroom. The keeper of the lighthouse across the way had a telegraph button that caused the sometimes-unwelcome disturbance. In 1919 though, the government sprang for a telephone connection between the buildings. (Cynthia Hagar Krusell.)

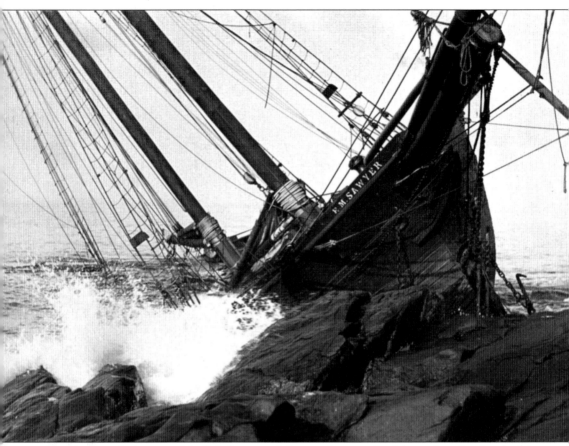

Despite the calming rays of the lighthouse and the warning sounds of the various fog signals, ships still found trouble along the Monhegan shore. The island's equidistant positioning between the Penobscot and Kennebec Rivers placed it as a halfway point for coasters moving between those bodies of water. Sometimes, as with the schooner *E. M. Sawyer* in 1905, Mother Nature won the ancient battle. The *E. M. Sawyer*, built in 1869 in Jonesport and home ported to Machias, had seen trouble before this fate. On February 13, 1901, the revenue cutter *Dexter* had to save it and four others from being crushed in ice during a northwest gale in Dutch Harbor, off Jamestown, Rhode Island.

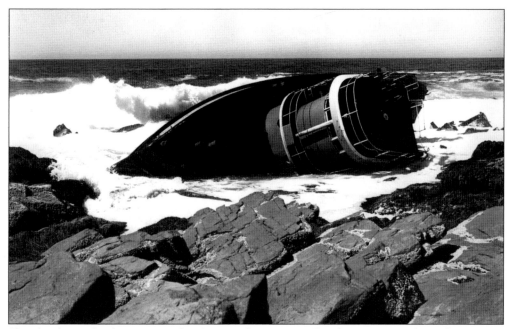

Shortly after midnight on November 6, 1948, the tug *D. T. Sheridan* ran aground at Lobster Cove, on the southeast corner of Monhegan. The *D. T. Sheridan* with two barges in tow, the *Blanche Sheridan* and the *Rockhaven*, was hauling coal to Rockland and Bangor when it got caught in heavy fog. U.S. Coast Guard crews from Burnt Island and Rockland rescued the captain and all nine crew members. A portion of the tug still sits on the rocks today.

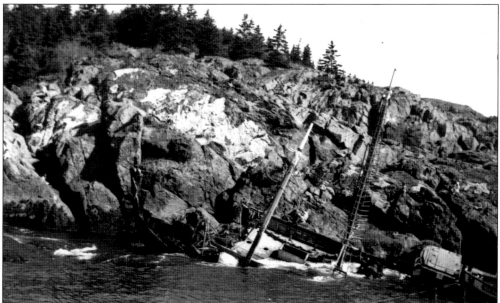

It only stands to reason that on an island full of artists, a shipwreck, with all its frenzied activity and human drama, should make a good subject, as did the wreck of the *St. Christopher* at Squeaker Cove in 1949. Alabama-born artist Joseph De Martini, an abstract artist from New York who joined the colony at Monhegan, found inspiration in the wreck, painting both *The Wreck at Squeaker Cove* and *The Wreck of the St. Christopher* in 1950.

The view from Lighthouse Hill encompasses many things, but perhaps for this small island community, it most ominously includes the island cemetery. Here are buried the island people of several generations, the descendants of the early settlers and those who have come here, fallen in love with this offshore place, and chosen to spend the rest of their lives here. The oldest stone is that of Phoebe Starling, who died on March 4, 1784, at the age of one month. One has to wonder, though, if there had never been a shipwreck-averting Monhegan Island Lighthouse or a danger-proclaiming Manana Island Fog Signal, would there be more strangers buried in the cemetery today than friends? (Cynthia Hagar Krusell.)

Seven

A FOREVER ISLAND

The idea of attempting to present the natural beauty of Monhegan Island through black and white imagery is, of course, absurd. Without the greens of the pines, the grays of the rocks, and the blues of the ocean, not to mention the rainbow unveiled each spring in the flowers, lichens, birds, and butterflies of the island, the images on the coming pages can only hint at the wonderfulness of Monhegan. The reader's imagination is called upon in envisioning the place where the forest meets the cliffs that meet the sea. (Cynthia Hagar Krusell.)

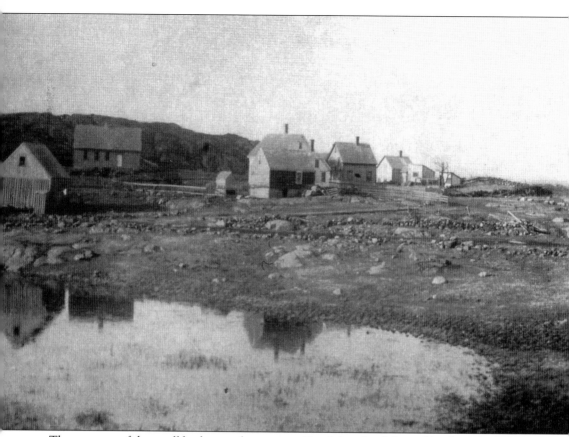

The presence of the small harbor on the western side of the island, formed by the western barrier of Manana Island and the low, small Smutty Nose Island somewhat forming a northern barrier, led to the settlement of the lands just ashore of Monhegan to the east. The presence of a nearby natural spring for fresh water no doubt helped with the decision. That freshwater source, known as the Meadow, has been dammed in the past for iceboating and for skating purposes but also plays a more important role. It is a hint at what is to come. Thanks primarily to the Monhegan Associates, but as well to a lack of hardiness in the human condition requisite for such a rugged life, most of Monhegan remains as wild as it ever was. Open space is the hallmark of Monhegan. (Cynthia Hagar Krusell.)

The name is descriptive enough: Cathedral Woods, a place so naturally beautiful that one wants to drop to one's knees and pray to the deity that created it. But it is the arching of the interlocking branches, reaching out to each other in sylvan brotherhood that gave the woods their name.

Artist E. T. Knowlton captured the woods' splendor in 1897. Spruce and balsam fir, as aromatic as they are eye pleasing, dominate the woods, yet a closer look reveals lush ferns and numerous species of wildflowers. Once settled and cleared and later abandoned, this regenerating forest is as vigorous as any on the coast of Maine.

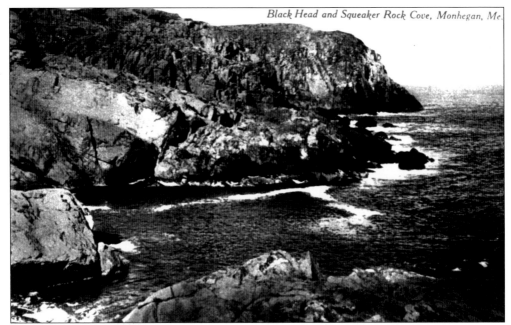

Some 11 miles of trails wind through the open spaces of Monhegan, so the old New England saying, "You can't get they-a from hee-ya" just does not apply on the island. There are many routes to take to find a destination like Black Head on the northeast end of the island. (Margot Sullivan.)

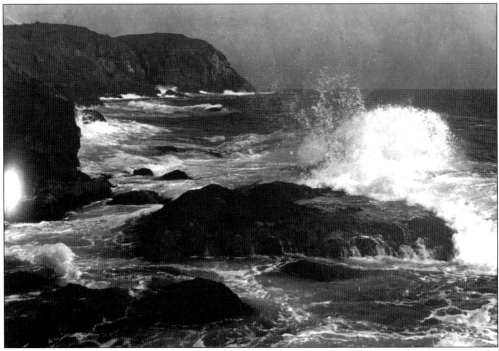

From the foot of Little White Head past Squeaker Cove, Black Head still dominates the scene. The exposed, eastern shore of the island faces the brunt of Poseidon's wrath as rock meets the sea, as illustrated here on September 22, 1921. Erosion is more evident on this section of the island than anywhere else.

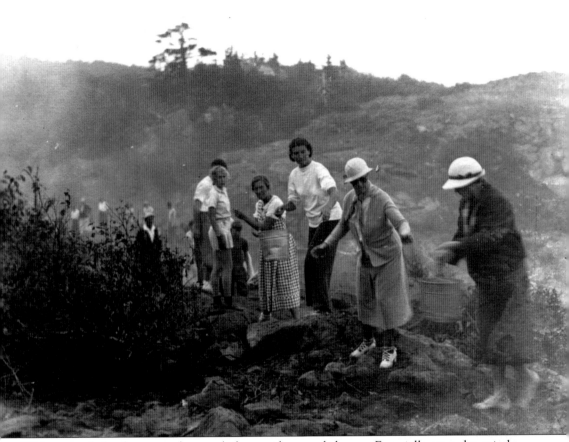

With so much land open and natural, fire can be a real danger. Especially on a dry, windy summer's day, when two of the three components of a good fire are already in place (oxygen and combustible material), all it takes is one spark of a flame to turn a delightful afternoon into a tragic one. In 1934, the worst of all possible scenarios took place when a fire broke out at one of the farthest points from the village, Black Head. It took a bucket brigade 72 people long to fight the fire. That summer's volunteer firefighting crew was larger than the winter population of the island. Because of the threat of fire, the Monhegan Associates have designated most of the island as a nonsmoking zone.

Well to the south-southwest, and at half the elevation of Black Head, sits Gull Rock. Trailways to reach it can be quite demanding, but the reward, when first spied through the outer edges of the forest, is obvious.

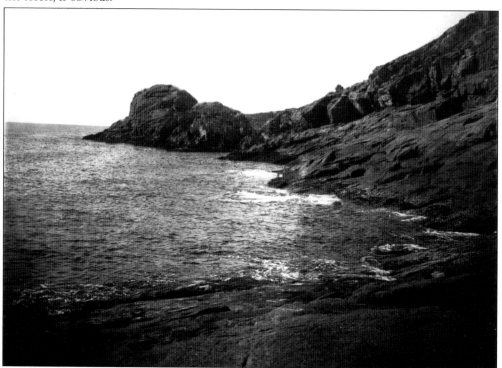

Examination of the fine grains of this huge chunk of bedrock exposes its fiery past. Gull Rock is comprised of gabbro, an igneous rock not unlike granite. To the wandering geologist, it is certainly a sight of interest; to the meandering trail walker, it is a beautiful place to sit and watch the power of the ocean.

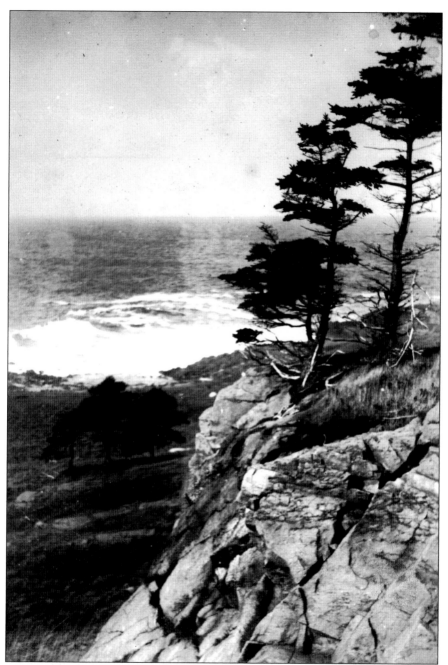

One need not be a Jamie Wyeth to enjoy the magnificence of Monhegan Island. One need not be Rockwell Kent to capture its essence. Even postcard photographers with basic training could bring a still scene to life a century ago. But Monhegan has benefited greatly from the presence of so many talented artists over the past 100 years. Their attention and their gifts have in turn given a gift to the island. They have given windswept trees and craggy outcroppings value. They have given far away dreamers reason to put Monhegan Island on the list of places they just have to visit before they die. Tourism has, in turn, given the people of Monhegan a reason to cherish what they have. One tends to believe they would have done that anyway. (Margot Sullivan.)

A good rock deserves a good name. Whether tossed upon the shore by a storm or dropped by a retreating glacier, a standout boulder can evoke anthropomorphic musings. Pulpit Rock, north of Black Head, calls to mind a podium behind which a dynamic preacher would bellow and pound his fist, exalting one and all to heed to words of scripture.

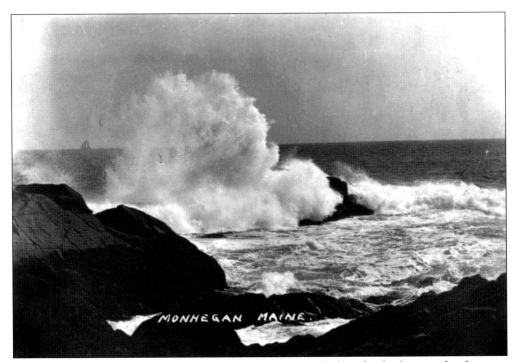

Other geological features suggest other human images. Bathed in the frothiness of a churning sea, offshore of Christmas Cove at the southern end of the island, the Washerwoman gets a soaking.

As described elsewhere in this book, an ice pond was an important commodity for any community in the 1800s, especially one hoping to pass itself off as a resort. Ironically an ice pond did its important work in the season opposite its usefulness. When the crowds have all cleared away and the need for ice is at its nadir, that is when the ice cutter goes to work. When the sun is high in the sky and the island is teeming with summer revelers, the ice pond is at rest. Its serenity in summer belies the image of its winter self. In fact, were it not for the presence of the icehouse at the far end, one might never recognize this pond for anything but a body of freshwater incongruously surrounded by saltwater. (Cynthia Hagar Krusell.)

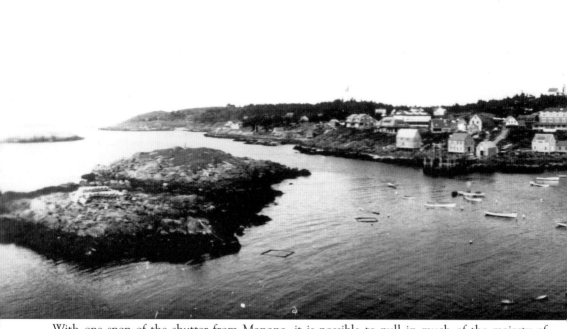

With one snap of the shutter from Manana, it is possible to pull in much of the majesty of Monhegan. To the left in this panoramic view, Smutty Nose Island disrupts the flow of water

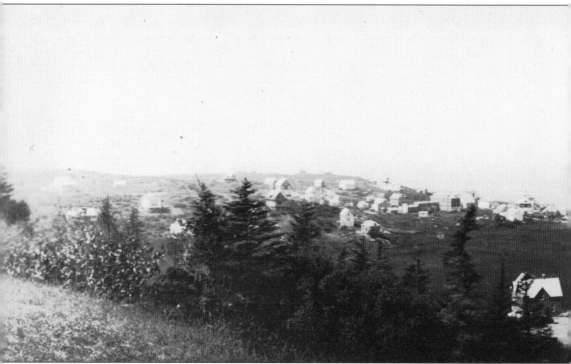

Of course, one good turn deserves another flash of the camera. The view from Monhegan pulls

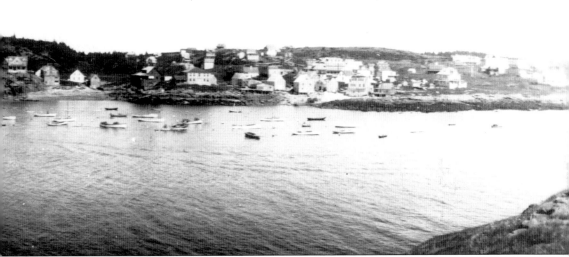

into and out of the harbor, allowing for boats of all sizes to ride quietly at anchor. At center, the village beckons for one and all to come ashore.

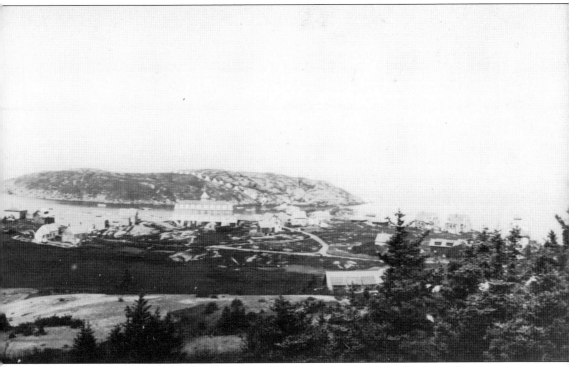

in the entirety of Manana Island, with much of the former caught in the foreground.

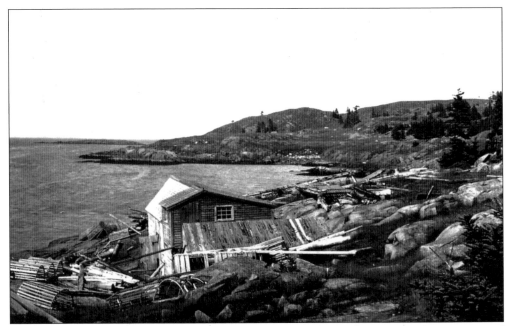

Monhegan exists for all to share, with the caveat that off-islanders respect the privacy and legacies of the islanders. It has been a place of work and a place of play, and it has been a place of inspiration. There is no perfect angle from which to view its beauty. (Cynthia Hagar Krusell.)

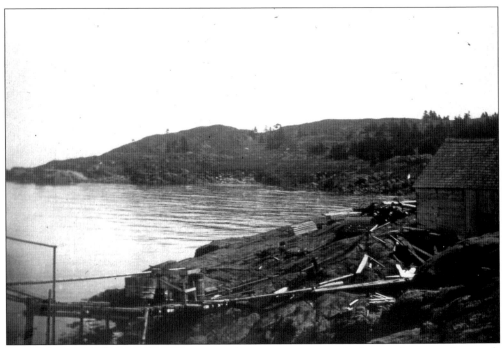

Even the slightest change of perspective can bring out newness, a freshness of scenery that sends the eye and the mind on a nomadic journey through geologic time, human time, and the flight of the seasons. No matter what happens to the humans inhabiting it in the future, Monhegan will always be a jewel. (Cynthia Hagar Krusell.)

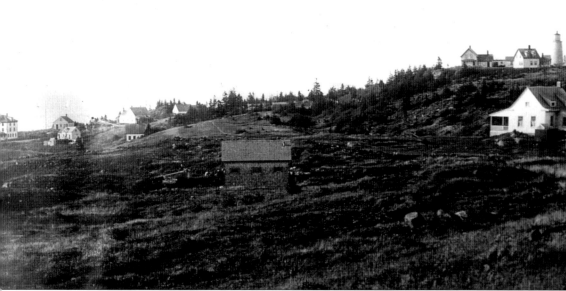

That is the future. But in looking to the past, one realizes that human love of the landscape has protected Monhegan Island, and reverence for nature has made the island what it is today. Sure there have always been necessities for the fishermen and lobstermen who have called it home, the construction of homes and work spaces for little more than basic needs. There have been extravagances from time to time, if one can call a tearoom lavish, but there never have been and never will be "McMansions" on Monhegan. So long as there are descendants of the old families still knocking about its village, waters, and trails, it will always remain Monhegan, forever island. (Cynthia Hagar Krusell.)

ACROSS AMERICA, PEOPLE ARE DISCOVERING SOMETHING WONDERFUL. *THEIR HERITAGE.*

Arcadia Publishing is the leading local history publisher in the United States. With more than 3,000 titles in print and hundreds of new titles released every year, Arcadia has extensive specialized experience chronicling the history of communities and celebrating America's hidden stories, bringing to life the people, places, and events from the past. To discover the history of other communities across the nation, please visit:

www.arcadiapublishing.com

Customized search tools allow you to find regional history books about the town where you grew up, the cities where your friends and family live, the town where your parents met, or even that retirement spot you've been dreaming about.